HIDDEN
HISTORY
OF
GREENVILLE
COUNTY

HIDDEN
HISTORY
OF
GREENVILLE
COUNTY

ALEXIA JONES HELSLEY

THE
History
PRESS

Published by The History Press
Charleston, SC 29403
www.historypress.net

Copyright © 2009 by Alexia Jones Helsley
All rights reserved

First published 2009
Second printing 2011
Third printing 2011
Fourth printing 2013
Fifth printing 2013

Manufactured in the United States

ISBN 978.1.59629.779.1

Library of Congress Cataloging-in-Publication Data

Helsley, Alexia Jones.
Hidden history of Greenville County / Alexia Jones Helsley.
p. cm.
Includes bibliographical references and index.
ISBN 978-1-59629-779-1
1. Greenville County (S.C.)--History. I. Title.
F277.G6H45 2009
975.7'27--dc22
2009030571

In memory of
Dr. Albert Neely Sanders, professor of history at Furman University,
who not only taught his students to love South Carolina history but
also taught them how to live.
III John 1:11 "The one who does good is of God."

And in honor of the Furman University
Class of 1967
"A mountain city is her home."

Contents

Acknowledgements

I gratefully acknowledge the assistance of Beth Bilderback, visual manuscripts curator, South Caroliniana Library; Steve Tuttle and Bryan Collars, South Carolina Department of Archives and History; Elizabeth Johnson, deputy state historic preservation officer; Mary Jo Fairchild and Jane Aldrich, South Carolina Historical Society; Fritz Hamer, South Carolina State Museum; Heidi Williams, *G: A Magazine of Greenville*, whose interest sparked much of the research for this book; and Laura All, senior commissioning editor at The History Press, for her unflagging encouragement and patience. I send a special thank-you to William E. Benton, who once again shared his wonderful collection of South Carolina images.

In the course of writing this book, I shared several adventures with my husband and granddaughter while locating sites discussed in this book. On one such adventure, we met Tom Owens, who shared his knowledge of the Battle of Great Cane Brake marker and the history of the Harrison Bridge area.

In addition, such a project could not succeed without the support of my family: Cassandra, Johnny, Keiser, Jacob and, especially, my husband Terry. Terry was chauffeur, photographer, encourager and indexer for this project.

A GEM IN THE LAND OF THE SKY

G reenville County is an area of great natural beauty, rich soil and mineral wealth. It also has a long history as a manufacturing and educational center. Its location, bounded on the north by the state of North Carolina, historically tied the Greenville area to Western North Carolina. Although the first European settlers who entered Greenville were from Virginia, by the 1790s Greenville shared more ties with Asheville, North Carolina, than with Charleston, South Carolina. As Upstate South Carolina and Western North Carolina became summer retreats for wealthy South Carolinians, Greenville was a destination and an important link in the transportation chain that connected the Lowcountry elite with their summer destinations. The nineteenth century was a time of crucial change and growth for Greenville. Choices made then continue to have an impact on Greenville in the twenty-first century.

The Greenville of today owes much to the dynamic interaction of a remarkable group of men whose public careers intersected as the nineteenth century unfolded—men such as Lemuel Alston, Elias Earle, Vardry McBee, Joel R. Poinsett, Benjamin F. Perry and James C. Furman. These leaders set the course for Greenville to develop as an educational and commercial center. They promoted intellectual life—schools and churches. They built roads and lobbied for railroads to connect Greenville with other markets in the Carolinas and Tennessee. They promoted the benefits of Greenville's climate as a summer residence for Lowcountry planters and as a health resort. They opened mills and factories and sought to diversify the area's economy.

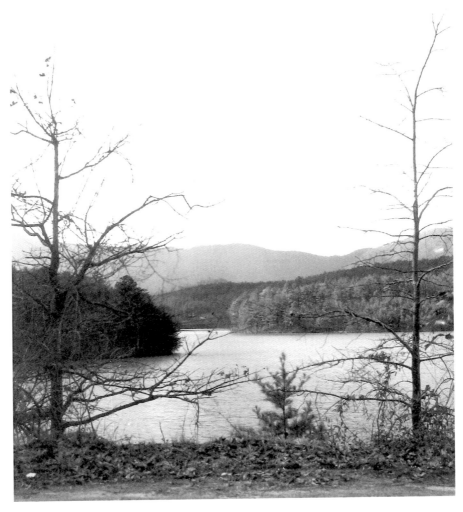

Greenville County landscape. *Courtesy of the South Caroliniana Library, University of South Carolina, Columbia.*

These men set the stage for Greenville to become a cultural and commercial center. The lives of these men and many others are interwoven in the history of the city and county. They held different political and economic views, but together they produced the synergy that made Greenville a forward-looking

A Gem in the Land of the Sky

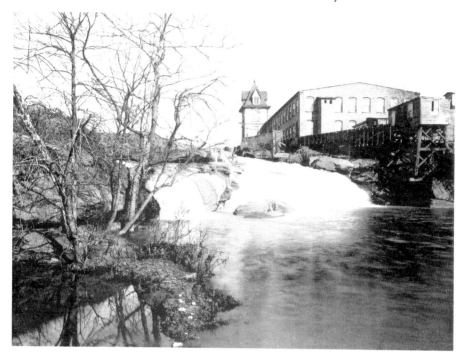

Reedy River and Falls, Greenville, 1895. Art Work Scenes in South Carolina. *Courtesy of South Caroliniana Library, University of South Carolina, Columbia.*

Upstate community. Each saw potential in a small town that began its life as "Pleasantburg at Greenville Courthouse."

Greenville County owes much to Lemuel J. Alston. During those difficult years following the American Revolution, Alston purchased land around the Reedy River that had formerly belonged to the Loyalist Richard Pearis. Pearis had operated a gristmill and trading post near the falls of the Reedy River. When Greenville County was created in 1786, Alston offered land for the courthouse and jail. Although laid out as Pleasantburg, the site quickly became known as Greenville Courthouse. In 1788, as the new United States moved from the decentralized government of the Articles of Confederation to the centralized federal vision of the Constitution, South Carolina was making its own adjustments to the new order. Historically, the Carolina backcountry had been underrepresented, denied easy access to courts and justice and overtaxed. In 1785, South Carolina divided the state into counties, with local officials

and records keeping. In 1786, after acrimonious debate, the state legislature voted to create a new centrally located capital—Columbia—equally accessible from all regions in the state. These and other concessions by the Lowcountry brought needed change and an easing of tensions between the Upstate and the Lowcountry. In time, with the Compromise of 1808, the more populous Upstate gained more equal representation in the South Carolina legislature and improved access to justice.

Greenville's first courthouse was a log building, and the village, officially laid out in 1797, grew slowly. In 1805, a visitor called the village "pretty and rural," with grass-covered streets. The site was considered "healthy" but not a business destination. Yet developments were underway to transform the sleepy little village. Greenville had a post office, and stagecoaches brought visitors to town. Accessibility improved as the year 1797 also saw the opening of the wagon road that ran from Greenville over the mountains to the Green River Cove, on to Asheville and across the mountains to Knoxville. This road was the beginning of the great north–south trade between the South Carolina Upstate and farmers and livestock raisers of Western North Carolina and Tennessee. Such trade demanded more inns and rest areas along the route. Feeding the herds of turkeys, cattle, mules, hogs and horses that traveled the road gave local farmers needed outlets for their produce. In time, other roads would cross the region, but the first rung of the ladder was in place.

The next rung in Greenville's climb from obscurity was the textile industry. Despite earlier local efforts, the major boost for the textile industry came after the War of 1812. The second war for American Independence emphasized the need for improved manufacturing in the states. Rhode Island industrialists expanded their operations into the South Carolina Upstate. By 1820, textile mills were operating in Greenville. As the Rhode Island presence expanded, so did interest among Greenville residents. Vardry McBee, for example, operated a textile mill at Conestee on the Reedy River. With these early mills came millworkers and mill villages. These early mills were the seeds for Greenville's post–Civil War renaissance as a textile center.

Another post–War of 1812 development was the increase in summer visitors. Greenville took its place as a healthy alternative to the malarial Carolina coast. For example, Henry Middleton purchased land from Elias

A Gem in the Land of the Sky

Earle and built his summer home, Whitehall, in Greenville. In 1824, Colonel William Toney built the Mansion House, a resort hotel, on South Main, now the site of the Poinsett Hotel. Modern Greenville still attracts retirees and "summer" visitors. Despite these changes and improvements, Alston despaired of his investment. In 1815, he sold 11,028 acres, the central part of modern Greenville, to Vardry McBee, a North Carolina businessman, for $27,550 and relocated to Mississippi.

By 1826, according to Robert Mills, Greenville had a population of five hundred and numerous amenities, including a jail, a courthouse, male and female academies and two churches. With no banks, individuals loaned money at interest. The mail arrived once a week, and when court was in session, large crowds flocked to Greenville to see and be seen. Monthly sales days were other popular times of socializing that included horse racing and other forms of entertainment.

The new State Road, the opening of Furman University and the Greenville Women's College and the arrival of the railroad heightened Greenville's antebellum prosperity even as the state slipped closer to secession. Greenville residents and annual visitors, such as Benjamin F. Perry and Joel R. Poinsett, protested the moves toward nullification and secession. Politics was a hotly and frequently debated topic. Competing newspapers argued unionist and secessionist ideologies.

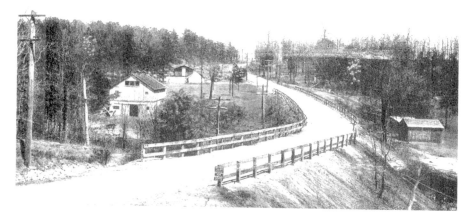

Greenville County Road, circa 1918. *E.C. Kroff Co. Courtesy of William E. Benton.*

JAMES C. FURMAN

Among those arguing proslavery was James C. Furman. James Clement Furman was a minister, educator and political activist, as well as a wealthy planter. Devoted to religious education and states' rights, the latter issue often competed with the pursuit of his religious calling. Perhaps his greatest legacy, however, was his service to Furman University, now ranked as one of the top liberal arts colleges in the United States.

Furman, born December 5, 1809, in Charleston, grew up in the shadow of his father, the renowned Dr. Richard Furman, a great Baptist preacher and denominational leader. Furman studied at the College of Charleston and, in 1828, felt called to the ministry. That year, Furman listed nine resolutions in his diary. The last one read, "Resolved, never to halt in doing anything of which I am convinced that it is duty." In 1830, he enrolled in the Furman Theological Institution, then located at the High Hills of the Santee. In 1832, Furman was ordained to preach.

In 1845, he joined the Furman (then located in Fairfield County) faculty. Furman University was named for his father, Richard, who worked for its creation. James C. Furman was instrumental in moving the school to Greenville, where in 1851 it opened in McBee Hall on the corner of Main Street and McBee Avenue. A small, frame structure that housed classrooms in those early years now stands beside the lake on the Furman campus. Furman was chair of the faculty and later president of the university.

During the fateful year 1860, Furman, as a states' rights leader, opposed the National Democratic Party meeting in Charleston. When the Democratic Party refused to guarantee slavery in the territories, the states' rights faction bolted and called for local elections to choose delegates for a new state convention. That state convention would, in turn, select delegates to a States' Rights Democratic Convention in Richmond. Furman was a leader in the Greenville District meeting. At a November 17 meeting endorsing the forthcoming convention to consider secession, Furman was one of the featured speakers. It is little wonder that Furman was one of the Greenville delegates to the Secession Convention in December 1860. On December 20, he was one of the signers of the Ordinance of Secession.

A Gem in the Land of the Sky

With its students serving in the military, Furman University closed during the Civil War. James C. Furman became president of the Greenville Women's College. When the war ended, times were difficult for the university. The first effort to reopen failed, but President Furman persevered: "I have resolved, if the university should go down, to sink with it." His dedication succeeded and so did Furman.

On October 12, 1870, James Clement Furman spoke at a special Greenville commemoration of the death of Confederate general Robert E. Lee. In 1872, when the Grange, a farmers' advocacy group, organized in Greenville, members elected Furman as chaplain.

Furman married twice. His wives, Harriett and Mary Davis, were sisters. Furman died on March 3, 1891, at his home, Cherrydale. Moved to the Furman campus, Cherrydale now serves as the university's alumni house. Furman was buried at Springwood Cemetery.

By the outbreak of the Civil War, Greenville, despite small efforts toward manufacturing, remained primarily agricultural. As secession approached,

Gilreath Mill, near Greer, is one of the few mills left in Greenville County. As at the Reedy Falls, early residents used the region's rivers to power grist- and sawmills. *Records of the National Register of Historic Places, Greenville County. Courtesy of the South Carolina Department of Archives and History.*

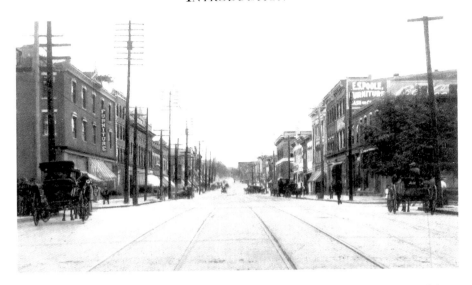

Main Street, looking north, Greenville, South Carolina. *Postcards, gree. co. 31. Courtesy of the South Caroliniana Library, University of South Carolina, Columbia.*

cotton was gaining on corn as the area's main crop. In 1860, Vardry McBee was still the largest landowner in the area. He also had the most diverse portfolio—land, manufacturing and farming. Most Greenville farmers did not own slaves and raised cattle and food crops. In 1860, only one Greenville County resident owned one hundred or more slaves.

The town of Greenville mirrored the district's prosperity. The town boasted a population of 1,815. An onlooker commented, "All who work are doing well." Sale days were still main attractions to bring country dwellers to town. The town provided pasturage for residents' cattle near the Springwood Cemetery, which opened in 1829. Residents lived near their work. Shops offered a variety of goods—cloth and clothing, shoes, saddles, farm equipment, seeds and tools. There were tailor shops, livery stables and, after 1826, a newspaper.

Thus, almost from its founding, Greenville developed a diversified economy. The area was productive for agriculture; had water to power gristmills and other manufacturing enterprises; and lay on a major wagon road that connected Greenville, South Carolina, with Greeneville, Tennessee. The healthy climate and breathtaking views of the mountains entranced

Caesar's Head, the iconic landmark of upper Greenville County. *Carlisle Robert, WPA-PL-GV-5. Courtesy of the South Caroliniana Library, University of South Carolina, Columbia.*

visitors. Greenville, the county seat, prospered under the adroit leadership of Vardry McBee and other visionaries who paved the way for modern Greenville. They fostered civic pride, education, religion, transportation and commerce.

This book celebrates the uniqueness of Greenville, the city and the county. It explores lesser-known aspects of the area's history and the fascinating men and women whose stories bring that history to life.

THE LAW ON THE REEDY

Richard Pearis

The lure of Cherokee land brought Richard Pearis to Greenville. Pearis, born in Ireland in 1725, was a planter, Indian trader, agent and Loyalist. At age ten, he immigrated with his parents, George and Sarah Pearis, to the Shenandoah Valley of Virginia. His parents were devout Presbyterians who prospered in the New World. By 1750, the twenty-five-year-old Pearis had married and acquired land near Winchester, Virginia. His father died in 1752, and within a few years, Pearis began trading with the Cherokees. At different times in his career, he served as Indian agent for Governor Robert Dinwiddie of Virginia and, after 1763, for the colony of Maryland. At one point, he had a trading center for the Overhill Cherokees near the site of Knoxville, Tennessee. That effort was short-lived, and by 1754, Pearis had shifted his focus to trading with the Lower Cherokee towns in South Carolina.

Pearis distinguished himself during the French and Indian War. He led a company of Cherokees that patrolled the Virginia and Pennsylvania border, and he served under General John Forbes during the retaking of Fort Duquesne (Pittsburgh). By 1769, Pearis and a Virginia neighbor, Jacob Hite, had become interested in acquiring land in the Greenville area. On July 29, 1769, leaders of the Lower Cherokee towns deeded Pearis twelve square miles—a tract that extended across the Reedy and Saluda Rivers. In May 1770, Pearis arrived from Virginia with wagons of trade goods, and in June, the entrepreneurs, Hite and Pearis, crossed the mountains to gain approval for the land transfer from the Cherokee chiefs at Chota.

Pearis needed all the Cherokee backing he could muster because after the 1772 survey of the line between North and South Carolina, the Pearis tract lay within the bounds of South Carolina. South Carolina officials invoked an old 1739 statute that prohibited British citizens from owning Indian land and threatened Pearis with prosecution. Unfortunately, Pearis had already begun subdividing and selling portions of his holdings to other Virginia investors and/or possible settlers. Baylis Earle was one of these early purchasers.

In November 1773, Pearis and Jacob Hite were tried at Ninety Six and found guilty of owning Indian land. Pearis surrendered his original deed, but in December 1773, undeterred by the setback, he secured another one. The new deed, signed December 21, 1773, by three Cherokee chiefs—Uconnastotoh, Willinawauh and Ewe—granted Pearis's Cherokee son, George, not only the original twelve-square-mile tract but also over fifty thousand additional acres. According to the deed, the tract lay within the Cherokee boundary and included the north and middle forks of the Saluda and the headwaters of the Enoree River near the "middle fork" of the Tyger River. Following the land transaction, George Pearis then became an English citizen. A few months later, on April 7, 1774, George Pearis, styling himself the "natural son" of Richard Pearis, in turn, legally an Englishman, conveyed to his father a tract of land on waters of the Saluda, Reedy and Tyger Rivers. Pearis did not record either deed until 1782, during the British occupation of Charleston. Richard Pearis adroitly skirted the law, but his victory was short-lived.

About 1770, Richard Pearis moved his family—wife Rhoda and children Richard, Elizabeth and Sarah—from the Shenandoah Valley of Virginia to his new landholdings on the Reedy River. With twelve slaves, he began clearing about one hundred acres for cultivation near the falls of the Reedy River. Pearis planted orchards on his plantation, which he called the Great Plains, and raised wheat and livestock. He built a large home and a trading post east of the falls. Pearis also established saw- and gristmills on the Reedy—the site of the future city of Greenville. Pearis had other developments within his extensive landholdings. In addition, he sold acreage on the Enoree River to Jacob Hite, who relocated his family there from Virginia in 1775. The move had fatal consequences, as a Cherokee raid in July 1776 killed or captured the Hite family. In his British claim, Pearis also mentioned a number of

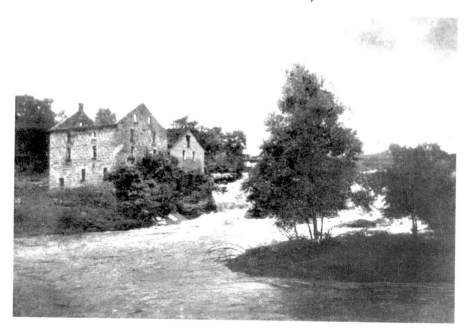

Ruins of Vardry McBee's stone mills at the falls of the Reedy River. Richard Pearis was the first European to operate grist- and sawmills on the river. *Postcards, gree. co. 55. Courtesy of the South Caroliniana Library, University of South Carolina, Columbia.*

outbuildings—stables, a dairy, a smokehouse, a blacksmith shop—as well as twelve slaves, horses, cattle, sheep, goats and hogs.

The French and Indian War (also known as the Seven Years' War or the Great War for the Empire) was a turning point for the American colonies and for Richard Pearis. In the postwar years, growing dissatisfaction with Crown policies and a stream of new taxes led the thirteen colonies to seek their independence from Great Britain. The ensuing conflict, the American Revolution, eventually brought an end to Pearis's Reedy River domain.

Originally siding with the Patriots, Pearis sought an appointment from the new state government as Indian agent. When another gained the coveted position, Pearis became a man of conflicted loyalties. Feeling ill-used by the Patriots, he allied himself with such Loyalist leaders as Colonel Thomas Fletchall and Robert Cunningham and accepted a Loyalist commission as captain. Pearis encouraged others to support the Crown and fought with the Loyalists at the Siege of Ninety Six in 1775. In his claim to the British

government for compensation after the Revolution, Pearis alleged that he had driven seven hundred Patriots out of Ninety Six District.

On December 8, 1775, Colonel Richard Richardson issued a proclamation demanding that all Loyalists surrender themselves and any powder or arms being held for the Cherokees. Then, on December 12, 1775, Colonel Richard Richardson and his troops captured Pearis and seven other Loyalists: Thomas Fletchall, Phillip Wells, James Davis, Captain McDavid, Joseph Henderson, John M. Williams and Captain George Sublegh. Richardson accused them of furnishing gunpowder to the Cherokees, and on December 16, Richardson sent Pearis, Fletchall and the other Loyalists under guard to Charleston. In his letter of transmittal, Richardson wrote that it would be "dangerous for me however Inocent [*sic*] they may appear before you to let either [*sic*] of them go." Richardson's son accompanied the prisoners to Charleston.

In January 1776, Pearis wrote to William Henry Drayton protesting his incarceration, alleging his innocence of the charge and demanding a hearing

The George Salmon house, near Tigerville. Salmon, a farmer and surveyor, was one of Greenville's early settlers. *Records of the National Register of Historic Places, Greenville County. Courtesy of the South Carolina Department of Archives and History.*

before the Council of Safety, an arm of the South Carolina Provincial Congress. Despite his protestations, the Patriots kept Pearis in irons in Charleston for nine months. During that time, Major Andrew Williamson ordered the Pearis plantation burned, as it was a gathering point for Loyalists in the Upstate. Consequently, Captain Leroy Hammond, Colonel Ezekiel Polk and Colonel John Thomas and their men attacked and burned Great Plains. Loyalist sources (for example, the journal of Alexander Chesney) allege that Pearis's wife, son and two daughters were at home during the attack and were forced from the property without food, water or adequate clothing. Patriot forces seized Pearis's stock and slaves and had them transported to Fort Prince in Spartanburg County, where they were sold at auction.

Upon his release, Pearis sought compensation for his losses, but he was only partially successful. He then traveled to British West Florida and, at Pensacola in 1777, received a captain's commission with the West Florida Loyalist militia. During the American Revolution, Pearis continued to support the king's cause, although not without personal conflicts with other Loyalist officers. He generally operated along the Gulf Coast and in Georgia.

In June 1781, Pearis's military career ended abruptly with the fall of Augusta, Georgia. Captured by Patriot forces, Pearis barely escaped with his life. Only the timely intervention of Patriot General Andrew Pickens, the legendary "Wizard Owl," and another upcountry man with Cherokee connections saved Pearis. Pickens had him placed in a boat and taken down the Savannah River to safety.

In 1782, the South Carolina General Assembly, at its first session since the British occupied Charleston in 1780, confiscated the property of many Loyalists. In 1784, the state disallowed all land titles, including that of Richard Pearis, lying beyond the Cherokee line. However, individuals who had purchased land from Pearis were permitted to retain their land. On his side, Pearis claimed that his losses of land, improvements, stock and slaves exceeded £15,000. As compensation, the British government awarded Pearis £5,624, slightly more than a third of the amount claimed, for his losses in South Carolina. He also received an annual military allowance of £70 from the British government until his death.

After the Revolution, Pearis and his family relocated to the Bahamas. There, on the island of New Providence, Richard Pearis, the elder, executed

Petition of Richard Pearis, the younger, for permission to import sixty slaves, as he wanted to settle in South Carolina, the home of his wife. *Records of General Assembly, Petitions, 1800 #161. Courtesy of the South Carolina Department of Archives and History.*

his last will, dated December 9, 1790. Pearis named as heirs his wife, Rhoda; son, Richard; daughters, Sarah and Margaret; and three grandchildren, Richard, Robert and John Pearis Cunningham. Pearis's last will did not mention his Cherokee son, George, who had played such a crucial role in the acquisition of the Reedy River property. At that time, he had extensive real estate holdings in Nassau, on the Island of Abaco, at Rum Key, on the Caicos and on the Pascagoula River in West Florida. In 1794, Richard Pearis, the sixty-nine-year-old Greenville pioneer, died far from his Reedy River estate. His will was proved on December 15, 1794. His death closed

Paris Mountain State Park. The name of Paris Mountain honors Richard Pearis, early settler near the falls of the Reedy River. *Courtesy of Terry L. Helsley.*

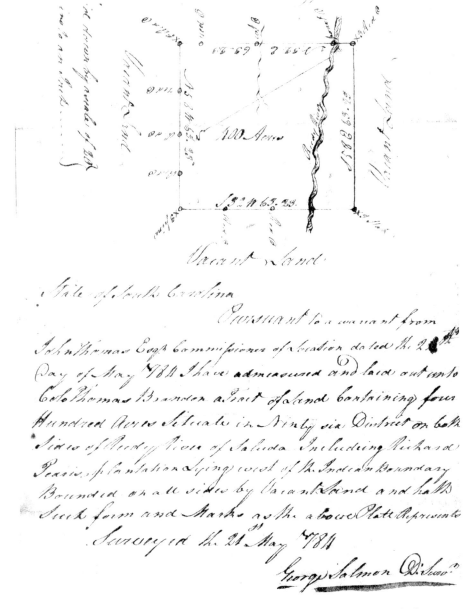

Colonel Thomas Brandon's plat for four hundred acres on the Reedy River, including Richard Pearis's former plantation near the falls of the Reedy River. George Salmon surveyed the tract on May 21, 1784. *Records of the Secretary of State, Office of the Surveyor General, vol. 1, p. 26. Courtesy of the South Carolina Department of Archives and History.*

a turbulent chapter in early Greenville history. Yet Paris Mountain, named for him, is a constant reminder of early Greenville's debt to this colorful and controversial character.

By the Treaty of DeWitt's Corner in 1777, Pearis's former associates and trading partners, the Cherokee Nation, relinquished most of the remaining Cherokee lands in South Carolina, including Greenville, Spartanburg, Pickens and Anderson Counties. South Carolina established a land office in the Upstate to issue warrants for the former Cherokee and Pearis lands. Revolutionary hero Colonel Thomas Brandon of Union was one of those who acquired former Pearis land. In 1784, Deputy Surveyor George Salmon, an early area resident who had witnessed Pearis land transactions, laid out four hundred acres for Brandon "in Ninety Six District on both sides of Reedy River of Saluda Including Richard Pearis plantation Lying west of the Indian Boundary." Brandon, a native of Pennsylvania, served as colonel of the Spartan Regiment during the Revolutionary War. In 1799, Brandon sold the four hundred acres, including Pearis's Great Plains and the falls of the Reedy River, to Lemuel J. Alston, an early promoter of the Greenville area.

On the ruins of Richard Pearis's plantation, Lemuel Alston would lay the groundwork for a new town—Greenville, South Carolina.

THE BATTLE OF
GREAT CANE BRAKE

Snow Campaign of 1775

In 1775, the South Carolina backcountry was a lawless region. Despite the earlier success of the Regulator movement and passage of the Circuit Court Act of 1769 that authorized courthouses and jails in the backcountry, it was 1772 before most district courts were functioning. Even with local justice available, gangs of disgruntled whites, mulattos and escaped slaves roamed the thinly settled backcountry. They preyed on lonely homesteads and made the roads unsafe for travel. By 1775, many of these disaffected men had allied themselves with the Cherokees to raid the frontier settlements. In addition, most disdained the fledgling Patriot efforts to create a new government in Charles Town free of Crown interference. Many were Loyalists. Such widespread disaffection prompted the Council of Safety to fight fire with fire. The waning months of 1775 were ones of unrest for the Carolina backcountry.

Both Patriot and Loyalist supporters jockeyed for position and influence in the region. In late October, the Council of Safety, a group appointed by the First Provincial Congress in 1775, moved to secure the backcountry and quell unrest. In an effort to curry favor with the Cherokee Nation, the council sent them a gift—a wagon of gunpowder. It was almost hunting season, and the Cherokees were short of powder. Normally, the colony's government had supplied the hunting needs of the Cherokees. However, leery of the Patriots' motives, a Tory band led by Patrick Cunningham intercepted the ammunition. Patrick Cunningham was a member of a large

Snow-covered road near the summit of Paris Mountain, 1895. Art Work Scenes in South Carolina. *Courtesy of the South Caroliniana Library, University of South Carolina, Columbia.*

and active Loyalist Upstate family. His brother was Brigadier-General Robert Cunningham. Neither the Loyalists nor the Patriots wanted the other to gain the support of the Cherokees. Both groups, while attempting to recruit new followers, spread rumors discrediting the other's intentions concerning providing ammunition to the Indians. Each side feared the other would ally itself with the Cherokees and wage bloody war on the other.

At Ninety Six in November 1775, a Patriot force under Major Andrew Williamson (circa 1730–1786) and Major James Mayson clashed with Loyalists commanded by Major Joseph Robinson and Captain (later Major) Patrick Cunningham. Williamson, later promoted to brigadier general, also commanded the successful expedition against the Cherokees in 1776. The Patriots constructed a hastily built fort on a hill near the town of Ninety Six. The fort, constructed of fence rails, beef hides and straw, connected several barns. The stream at the foot of the hill was the water supply for the

The Battle of Great Cane Brake

Letter of Richard Richardson, dated December 16, 1775, Camp Liberty, to Henry Laurens conveying Loyalist prisoners, including Richard Pearis. In 1775, Henry Laurens was president of the Council of Safety. *Robert W. Gibbes Collection, Box 2, folder 37. Courtesy of the South Carolina Department of Archives and History.*

town. In this precarious situation, five hundred Patriots held out against two thousand Loyalist militia for three days, November 19–21, 1775. Low on water and powder, the Patriot forces were in desperate trouble. Fortunately for them, Major Robinson, under a flag of truce, offered to negotiate an end to hostilities. The engagement at Williamson's fort was, according to Stanley A. South, "the first battle of the Revolution in the South." The battle also produced the first Patriot casualty—Joseph Birmingham. Captain Luger was the lone Loyalist death. Between 1970 and 1971, South and a team of archaeologists excavated the site. Those excavations uncovered two graves—one empty and one that may hold the remains of either Birmingham or Luger. The Battle of Williamson's Fort was only one of several engagements fought in the vicinity of Ninety Six.

By the time the affair at Williamson's fort ended on November 21, 1775, another expedition was headed to the backcountry. Seventy-year-old Colonel Richard Richardson's assignment was to arrest the Loyalist leaders in the backcountry and by that means bring peace to the area. Richardson was a prominent backcountry citizen who had served in the Cherokee War of 1759–60 and later helped negotiate a peaceful resolution of differences between the Moderators (a grass-roots movement to curb the excesses of the Regulators) and the Regulators (local vigilantes who first sought to curb lawlessness in the backcountry and then moved to enforcing societal norms and settling old scores). According to South Carolina historian Walter Edgar, Richardson was one of the most respected men of the Carolina backcountry. Richardson and Lieutenant Colonel William "Danger" Thomson marched twenty-five hundred troops into the Carolina backcountry. Those troops included Thomson's Third Regiment of Rangers, one of three regiments approved by the South Carolina Provincial Congress in June 1775. Other Patriot forces from North and South Carolina also joined the expedition.

On December 8, 1775, Richardson issued a proclamation ordering Cunningham's Loyalists to surrender and turn over all ammunition they planned to give the Cherokees. While pursuing Cunningham, on December 12, Richardson captured Richard Pearis and seven other Loyalist leaders. With their leaders captured, many of the Loyalist groups disbanded. However, one band, commanded by Patrick Cunningham, fled west of the Cherokee line. There were rumors that Pearis's son was seeking aid from the Cherokees. Learning that Cunningham and his followers were encamped on Cherokee land, Richardson sent Colonel William Thomson and thirteen hundred rangers and support troops to capture him.

After a hard twenty-three-mile march, Thomson and his men sighted the camp late on December 21. In the early morning hours of December 22, 1775, Thomson and his forces virtually surrounded and surprised the Loyalist encampment. The ensuing Battle of Great Cane Brake was a Patriot victory. Thomson and his men captured 130 Loyalists and killed 6. William Polk was the only Patriot casualty, but he survived. Unfortunately, Patrick Cunningham, the much-sought leader, riding bareback and in a state of dishabille, escaped. Telling his men to "shift for themselves," he fled to the Cherokee Nation. Although his lands were initially confiscated, in 1785

The Battle of Great Cane Brake

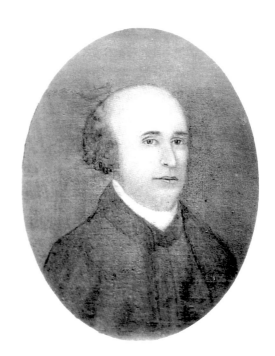

William "Danger" Thomson, commander of the Third Regiment of Rangers and hero of the Battle of Great Cane Brake. *Courtesy of the South Caroliniana Library, University of South Carolina, Columbia.*

Vicinity of the site of the Battle of the Great Cane Brake, South Harrison Bridge Road, Simpsonville. *Courtesy of Terry L. Helsley.*

the South Carolina General Assembly permitted Cunningham to return to South Carolina. At one point, Robert Cunningham, former Loyalist, even served in the South Carolina House of Representatives.

Although the exact location of the battle is subject to conjecture, the Great Cane Brake lay along the Reedy River in the southern portion of what is now Greenville County, roughly twenty-six miles from the Hollingsworth Mill on Rabun Creek. Prior to settlement and clearing, miles of thick reeds flourished in the rich bottomland along many Upstate rivers. These canes or reeds gave the Reedy River its name. The Saluda River was also known for its impenetrable cane brakes.

Affidavit of Archibald Brown, dated October 23, 1826, attesting to Benjamin Rowan's service in the "Snowy Campaign." *Records of the South Carolina Comptroller General, Accounts Audited for Revolutionary Service, AA 6641. Courtesy of the South Carolina Department of Archives and History.*

The Battle of Great Cane Brake

Despite the success of the expedition, the trip back to the Congarees was perilous. On December 23, snow began to fall, and it fell continuously for thirty-six hours. As a result, Richardson's men had to march through fifteen to twenty-four inches of snow. The troops, having been called to duty on short notice, did not have tents or other needed supplies, and their clothing and shoes, much worn from long marching, were inadequate for such a winter storm. Many suffered from the cold, exposure and frostbite. As a result of the unusual snowfall, the campaign was known as the Snow Campaign.

From South Carolina's Accounts Audited for Revolutionary Service, it appears that Benjamin Rowan of Chester was one of the South Carolinians involved in the so-called "Snowy Campaign." He had originally enlisted early in 1775 under Captain Ezekiel Polk in a militia unit attached to Thomson's Third Regiment. His petition to the legislature for a pension stated that he was present at the Loyalist "Defeat at Reedy River." According to historian Terry W. Lipscomb, Ezekiel Polk of the New Acquisition (York County) was the grandfather of President James K. Polk. James K. Polk, a native of Mecklenburg County, North Carolina, rose to political prominence in Tennessee as a friend of Andrew Jackson. Also part of Thomson's Third Regiment of Rangers was William Polk, the lone casualty. Polk, a North Carolinian, according to his petition to the South Carolina General Assembly,

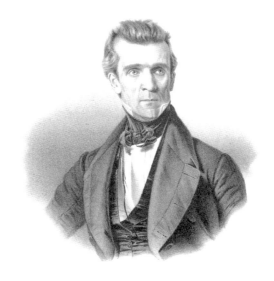

President James K. Polk (1795–1849). A political ally of Andrew Jackson and governor of Tennessee, Polk was president of the United States from 1845 to 1849. His tenure included the war with Mexico and the settlement of the Oregon/Canada boundary. *Courtesy of the Library of Congress.*

Affidavit of Zechariah Hill concerning Loyalist plans signed by Ezekiel Polk, August 13, 1777. *Robert W. Gibbes Collection, Box 1, Folder 47. Courtesy of the South Carolina Department of Archives and History.*

was wounded during "the expedition against the Tories on Reedy River." In 1786, he petitioned the South Carolina legislature, asking the State of South Carolina to reimburse him for his medical expenses.

After the American Revolution, in 1784, the State of South Carolina granted Colonel Richard Winn of Fairfield 640 acres on the Reedy River that included the site of the Battle of the Great Cane Brake. Winn, a

The Battle of Great Cane Brake

Former site of the historical marker commemorating the Battle of the Great Cane Brake, South Harrison Bridge Road, Simpsonville. *Courtesy of Terry L. Helsley.*

participant in the Snow Campaign, sold the property a few years later to Richard Harrison. Harrison, a wealthy merchant from Union District, acquired extensive landholdings in Greenville, built an imposing house and opened a store near the Great Cane Brake on the Reedy River. According to historian A.V. Huff, Harrison's store became the "mercantile center" of Greenville County.

In 1941, the Behethland Butler Chapter of the National Society of the Daughters of the American Revolution erected a marker honoring the Battle of the Great Cane Brake. The marker once stood on South Harrison Bridge Road, north of highway 418 in Simpsonville. Due to recent construction, when I visited the site in May 2009, the marker had been removed. According to local resident Tom Owens, this was the second time the marker had been moved.

The Simpsonville battle was an important early step in securing the Carolina backcountry.

CHAPTER 3

TOWN FOR SALE

Lemuel James Alston and Vardry McBee

Anumber of years ago, circa 1971, Hondo Crouch's purchase of Luckenbach, Texas, drew excited media coverage. Few believed that an individual could buy a town. Yet that is precisely what happened to Pleasantburg, the ancestor of modern Greenville, in 1815.

In 1786, the South Carolina legislature created Greenville County. The new county needed a courthouse, and both Lemuel James Alston (1760–1836) and Elias Earle had offered land for the new Greenville Courthouse. The South Carolina legislature accepted Alston's offer, triggering a long rivalry between two of early Greenville's key residents.

Alston, a prominent area resident and lawyer, had been a delegate in 1788 to the South Carolina convention to ratify the United States Constitution. He was also governor Joseph Alston's brother. Joseph Alston and his wife, the beautiful Theodosia, were frequent visitors at Lemuel Alston's fine estate, Prospect Hill. By 1789, Lemuel Alston had wide landholdings and over twenty slaves. A native of North Carolina and a Revolutionary War veteran, Alston moved into the Greenville area after the American Revolution and acquired the former site of Richard Pearis's Great Plains plantation. With the site of the courthouse set, Alston then laid out the village of Pleasantburg around the Greenville County Courthouse. The new town sat on hills just below the falls of the Reedy River and benefited from Elias Earle's wagon road and other transportation avenues. The wagon road, completed in 1797, connected Greenville with North Carolina and Tennessee markets. Both North and South Carolina were involved in constructing the road.

Plat for Lemuel James Alston showing seventy-four acres in Ninety Six District, in former Cherokee territory on branches of the Reedy River. Joseph Whitner surveyed the tract on August 19, 1786. *Records of the Secretary of State, Office of the Surveyor General, State Plats, vol. 16, p. 23. Courtesy of the South Carolina Department of Archives and History.*

Each assumed responsibility for its section of the project. In South Carolina, the wagon road was known as the State Road, and in North Carolina, the Buncombe Turnpike. The wagon road was one of the main north–south routes followed by drovers taking their livestock to market. As the number of travelers increased so did the demand for lodging, food and provisions for the stock.

ELIAS EARLE

Elias Earle's ancestors left England for Virginia in the 1600s. Members of the Earle family moved down the Great Wagon Road through the Shenandoah Valley to the Carolinas. In September 1787, Elias Earle moved to Greenville and in time acquired seven thousand acres and thirty-three slaves. He

Earle Town House, James Street, Greenville. The Earle Town House is one of the surviving structures in Greenville associated with the pioneering Earle family. *Records of the National Register of Historic Places, Greenville County. Courtesy of the South Carolina Department of Archives and History.*

supported efforts to relocate the Greenville courthouse near the falls of the Reedy River. The Poplars, Earle's home, was located in the center of Greenville County, just north of the Reedy River falls. He was disappointed, however, when the courthouse site chosen was on land of his rival, Samuel James Alston, and not on property Earle owned. Nevertheless, Earle was one of the original landowners in the village. He also owned property in Old Pendleton District, including Andersonville (Anderson). In 1813, Earle sold land to Henry Middleton for a summer home in Greenville—Whitehall.

Earle was a colonel in the South Carolina militia and, in 1802, founded ironworks on the north fork of the Saluda River. Despite his interest in manufacturing, Earle was primarily a planter. Greenville District elected him to both the South Carolina House of Representatives and the South Carolina Senate.

On December 1, 1794, the South Carolina Senate appointed Earle to a committee to consider the possibility of building a wagon road over the mountains of Western North Carolina. Such a road would connect Greenville and the Upstate with markets in North Carolina and Tennessee. The South Carolina legislature appropriated funds to construct a road "wide enough for four horses to pull a wagon with a load weighing one ton." The commissioners to oversee construction of the road contracted with Elias Earle and John William Gowen, a relative of Earle's, to build the road. By November 29, 1797, the road was completed.

From 1805 to 1807, Elias Earle served in the United States Congress. Vying for reelection in 1806, Earle faced two opponents, his rival Lemuel Alston and Dr. William Hunter. According to an observer, all three candidates converged on a militia muster in Pickensville (Pickens) with very different results. Hunter stayed in his room at the tavern while Alston recruited supporters on the street and then invited them to the barroom for drinks. Earle, however, perhaps understanding his audience better, set up a bench in the middle of the street and dispensed whiskey freely to all comers. Nevertheless, Alston won the election, but Earle later reclaimed his congressional seat.

Elias Earle died on May 19, 1823, and, along with his wife, Frances Robinson, is buried in the Earle Family Cemetery on Old Buncombe Road in Sans Souci. The Colonel Elias Earle Historic District in Greenville

Town for Sale

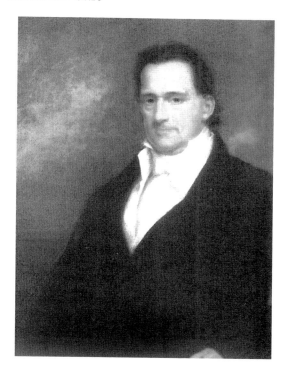

Elias Earle, one of Greenville's early landowners, helped build the State Road from Greenville to Asheville. *Courtesy of the South Carolina State Museum.*

commemorates the important role of Earle in the development of Greenville. The district includes two sites with Earle connections: the Earle Town House, at 107 James Street, and Whitehall, at 310 West Earle Street. Both sites were part of the original Earle holdings in Greenville.

As early Greenville developed, initial lot sales were slow, as few recognized the need for a new town. The plat that Alston filed in 1797 had eight blocks, four on either side of Richard Pearis's old road. Yet only two streets, "The Street" (Main Street) and "The Avenue" (McBee Avenue), were named. One of the early purchasers was Isaac Wickliffe, who bought two lots near the courthouse in 1797; the next year, John McBeth purchased the square south of the courthouse. Ten years later, half of the fifty-two lots remained unsold.

In 1805, a visitor to the area named Edward Hooker noted a two-story courthouse, several homes, a few shops, a large, three-story jail and grass-covered streets. Although considered a healthy location, Greenville was not yet a business center. The pace of life was quiet, except when court was

Earle Family Cemetery, Greenville. *Courtesy of Terry Helsley.*

in session or a group of drovers arrived with cattle, turkeys, horses and/or mules from Kentucky, Tennessee or Western North Carolina.

Lemuel J. Alston had political ambitions. He served in the South Carolina House of Representatives (1789–90), and in 1806, Alston successfully campaigned as a Jeffersonian Republican for the United States Congress. Defeating Elias Earle, his rival for the site of the courthouse, Alston served two terms in the United States House of Representatives (1807–11). Alston the campaigner attended church services and militia musters where he and the other candidates sponsored meals, addressed the voters and distributed free spirits. After Alston's two terms, Earle regained the seat. That loss was a factor in Alston's midlife decision to relocate to Alabama.

Disappointed in his investment, in his neighbors' lack of vision and the dashing of his political aspirations, Alston sold the town to Vardry McBee in 1815 and, in 1816, moved west. The fifty-five-year-old Alston settled at Alston Place, near Grove Hill in Clarke County, Alabama. In Alabama, Alston held several legal positions before his death in 1836.

Vardry McBee

The versatile Vardry McBee, known as the father of Greenville, was a pivotal figure in the history of the city and county. In 1815, he was already a successful businessman when he did the unthinkable—he bought the fledgling village of Greenville, all 11,028 acres. His vision and world view helped to create modern Greenville.

McBee, a product of the Carolina frontier, was born in 1775. The desperate fight for American independence shaped his formative years. His father and older brother fought with the Patriots at King's Mountain and Cowpens. Despite their patriotism, the Revolutionary War ruined many, including the elder McBee, and Vardry McBee had to make his own way in life. Lacking a formal education, McBee apprenticed himself to a saddle maker in Lincolnton, North Carolina, and pursued an ambitious program of self-education. He also worked in Charleston, South Carolina, and the states of Kentucky and Tennessee.

Returning to Lincolnton, McBee operated a general store—the first of many. There, he also studied scientific agriculture, founded male and female academies and, in 1804, married the well-connected Jane Alexander. His public activities in Lincolnton foreshadowed the civic-mindedness he demonstrated in Greenville. McBee valued education, hard work and a well-ordered society.

Although McBee did not relocate to Greenville until 1836, he promoted the town as a summer resort and industrial center. His business acumen was daunting; his ventures diverse. In Greenville, his mercantile establishment undercut the competition—offering moderately priced goods for cash. Across the Carolinas, he owned gold mines; textile mills (including the first on the Reedy River); wool, paper and flour mills; foundries; brickyards; quarries; tanneries; sawmills; and saddleries. An industrialist and philanthropist, he worked to diversify the southern economy, promoted railroad construction and contributed to the construction of schools and churches. In Greenville, he donated land for the city's first four churches and the male and female academies. His efforts influenced Furman University's move to Greenville and the development of Greenville Women's College. Ever the visionary, at age seventy-seven, he lobbied for the construction of a railroad to connect Columbia and Greenville.

Idyllic scene near the Furman campus, Greenville, 1895. *Art Work Scenes in South Carolina. Courtesy of the South Caroliniana Library, University of South Carolina, Columbia.*

Town for Sale

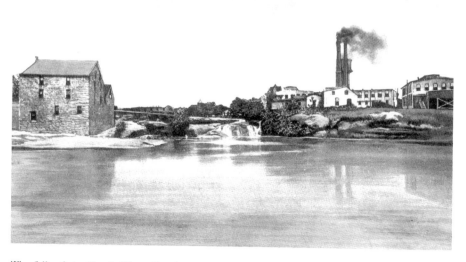

The falls of the Reedy River. On the left stand the stone mills of Vardry McBee and on the right, a portent of Greenville's manufacturing future. *Postcards, gree. co. 32 Courtesy of the South Caroliniana Library, University of South Carolina, Columbia.*

The town of Greenville grew and flourished under McBee's tutelage. By 1826, the area needed a bigger courthouse. Robert Mills, in his *Statistics of South Carolina* published that year, described the courthouse town as "beautifully situated on a plane, gently undulating." The town boasted not only a "handsome brick courthouse" but also a jail, Methodist and Baptist churches and the male and female academies. Presbyterians, Methodists, Baptists and Episcopalians all had meetinghouses in the area. Mills estimated that there were seventy houses in the town of Greenville, which had a population of 500. In 1820, the census reported a population for Greenville District of 14,530.

In 1852, McBee wrote his son: "A man should be prudent and careful" not a "bully of virtue nor a bigot." Another Greenville man of mark, Benjamin F. Perry, fittingly wrote of McBee: "Few men have appropriated so much [of their fortunes] to public improvement of their country in her agriculture, manufactures, schools, houses & public buildings, railroads."

A unionist, but not an abolitionist, McBee, along with Perry, opposed South Carolina's flirtation with secession in 1853. His efforts helped delay but did

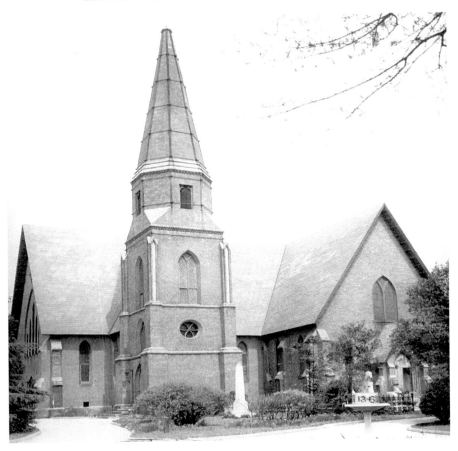

Christ Episcopal Church, Church Street, Greenville, 1934. Christ Episcopal Church is Greenville's oldest church. Buried in the historical churchyard are Vardry McBee, the father of Greenville, and Benjamin F. Perry, governor of South Carolina. *M.B. Paine, photographer, HABS SC,23-GREENV.1-1. Courtesy of the Library of Congress.*

not stop the state's move to secession. Vardry McBee died on January 23, 1864, at his home, Prospect Hill, high above the Reedy River. Prospect Hill is gone, but McBee's country home Brushy Creek still stands at the end of Rice Street in Greenville. The names of Greenville's McBee Avenue and McBee Methodist Church in Conestee honor Vardry McBee. Vardry McBee and his wife are buried at the churchyard of Christ Episcopal Church, Greenville.

Modern Greenville, city and county, benefited from the right men at the right time.

CHAPTER 4

OF MANSIONS AND BOARDINGHOUSES

Tourism

E arly in the nineteenth century, Greenville's healthy climate and auspicious location near the mountains and the Reedy and Enoree Rivers made it an attractive summer destination. Greenville booster Vardry McBee publicized the scenic attributes of Greenville as he promoted it as a summer resort. Lowcountry planters increasingly sought inland destinations to protect their families from the "miasmas" of the South Carolina coast. During the antebellum years, no one understood the role of insects in the spread of yellow fever and malaria. Waxing rhapsodic, Mills praised Greenville's climate as "the most delightful in the world." Summer visitors usually arrived in the spring and stayed until first frost in the fall.

By 1826, according to Robert Mills, the town of Greenville had three hotels or boardinghouses to accommodate visitors, and two of South Carolina's governors, Joseph Alston and Henry Middleton, had summer homes in Greenville District. Middleton, the owner of Middleton Place near Charleston, officiated as governor of South Carolina from 1810 to 1812. Henry Middleton also served as president of the Continental Congress, in the United States Senate and as a minister to Russia. In 1813, he purchased land from Elias Earle and built Whitehall. Whitehall, on Earle Street, is one of Greenville's oldest houses. Middleton used Whitehall as his summer home until 1820, when he sold the property.

Lemuel's brother, Joseph Alston, governor from 1812 to 1814, was a wealthy rice planter from the Waccamaw River region of Georgetown

View of Greenville from University Park, 1895. Art Work Scenes in South Carolina. *Courtesy of South Caroliniana Library, University of South Carolina, Greenville.*

District. In 1801, he married Theodosia Burr, daughter of Aaron Burr, controversial vice president of the United States who killed Alexander Hamilton in a duel. Alston acquired property on Pendleton Road for his summer retreat. Saddened by the deaths of his son and wife, the latter lost at sea, Alston died in 1816.

JOEL ROBERTS POINSETT

Joel Roberts Poinsett was another Lowcountry resident who acquired a summer place in Greenville District. Joel Roberts Poinsett, best known for bringing the poinsettia (*Poinsettia pulcherrima*) to the United States from Mexico, was a man of wide-ranging talents and a great interest in internal improvements. Born on March 2, 1779, Poinsett, like McBee, was a son of the American Revolution. He studied medicine and law and traveled widely. A national and international figure, Poinsett was also interested in natural history, science, politics and public improvements. He was the first consul-

general of the United States to Buenos Aires and Santiago, Chile. He also served as the first U.S. minister to Mexico from 1825 to 1830 and in the United States Congress from 1821 to 1825.

In South Carolina, Poinsett served in the South Carolina legislature and as the president of the Board of Public Works from 1819 to 1821. As president, he oversaw construction of the state road over Saluda Mountain. The state road ran from Charleston through Columbia and into North Carolina. The Poinsett Bridge (Gap Creek), built in 1820, on S.C. Secondary Road 42 near Tigerville, was part of the old state road. In addition to his interest in public improvements, Poinsett also joined Perry, McBee and others in support of the Union. Earlier, he had opposed John C. Calhoun and the ideology of nullification. In 1837, President Martin Van Buren named Poinsett secretary of war, a post he held until 1841. During his tenure in Washington, Poinsett and other like-minded men founded the National Institute for the Promotion of Science, a precursor to the Smithsonian Institution.

In 1833, he married Mary Izard Pringle, and by 1834, the Poinsetts were summer residents of Greenville. Homestead, their summer home, stood on the Pendleton Road west of Greenville. Poinsett landscaped the grounds to include hedges, flowers and an orchard. In 1845, he supported McBee and

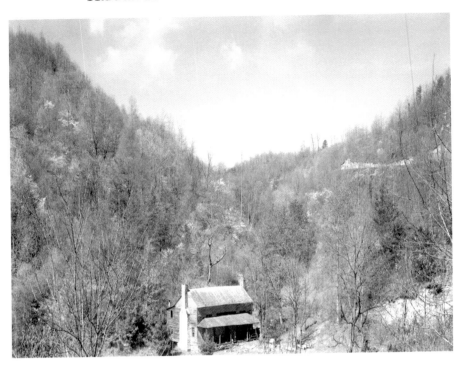

Homestead was the summer home of Joel R. Poinsett. *Courtesy of the Library of Congress.*

others in their efforts to develop the Greenville to Columbia railroad. He also served on the vestry of Christ Episcopal Church in Greenville. In 1851, en route from Charleston to Greenville, Poinsett's ill health forced a stop at Stateburg. There, at the Borough House, the home of Dr. William Anderson, Poinsett died on December 12, 1851, and was buried at the churchyard of the Church of the Holy Cross. His grave marker refers to Poinsett as "a pure patriot, an honest man, and a good Christian." The name of the Poinsett Hotel on Main Street in Greenville honors Joel R. Poinsett.

By the 1830s, Greenville was a well-known Upstate summer destination. Many owned summer homes or "summered" in Greenville's boardinghouses and hotels or with friends and relatives. For others, Greenville was a popular stop on the way to or from the springs and resorts of North Carolina and Virginia, such as Flat Rock, North Carolina and Warm Springs, Virginia. James Silk Buckingham commented in 1839 that Greenville had "an

established reputation" as a resort. Buckingham (1786–1855) was an English adventurer who traveled widely, published accounts of his travels and lectured in the United States on abolition and temperance.

In 1815, Edmund Waddell opened Greenville's first resort hotel in Prospect Hill, the former home of Lemuel J. Alston. Waddell rented the house from Vardry McBee and operated a successful hotel there until 1836, when McBee moved to Greenville and reclaimed his home. Soon after Waddell launched his venture, others, such as Captain David Long and Blackmon Ligon, also opened hotels or boardinghouses that catered to Greenville's burgeoning population of summer visitors. Long's hotel stood at the corner of Main and Washington.

THE MANSION HOUSE

Among the better known of antebellum Greenville's hotels was the Mansion House. In 1824, Colonel William Toney, one of Greenville's wealthiest residents, purchased two lots at the corner of West Court and South Main near the courthouse in order to construct a grand hotel. From 1816 to 1829, Toney, a successful businessman, had operated a store near the 1767 Cherokee Line. He was also a generous supporter and trustee of Greenville's male and female academies. Accordingly, Toney spared no expense in creating a hotel that excelled "any house in the upper part of the State in appearance and accommodation for the traveling public." The three-story brick Mansion House had heart pine floors, a circular staircase and a parlor with two fireplaces. The handmade brick walls were up to twenty-four inches thick. Most rooms had fireplaces, and there was a hand-operated elevator for luggage. Marble tiles, the first in Greenville, paved the lobby. The basement featured a card room that opened onto an outdoor court.

Given the level of consumption in Greenville at that time, the Mansion House furnishings were extravagant. For example, the Mansion House had carpets and one of the first sofas in Greenville. According to James M. Richardson, its cut-glass chandelier was the first in Greenville. Gracious hospitality, fine food and spacious rooms made the Mansion House an instant success. It was the preferred destination for Lowcountry residents, many of

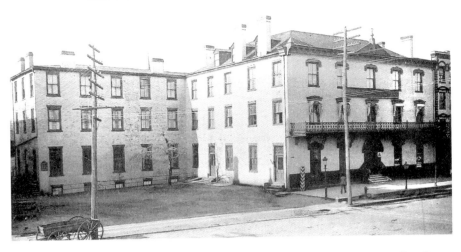

Mansion House, Greenville's first elegant hotel, 1895. *Art Work Scenes in South Carolina.*
Courtesy of the South Caroliniana Library, University of South Carolina, Columbia.

whom arrived with carriages and wagons loaded with baggage and servants. Stages from Columbia, Augusta and Asheville also deposited new arrivals at the Mansion House's door. The Mansion House catered to a discriminating clientele. Prior to his marriage in 1836, bachelor Benjamin F. Perry, one of Greenville's outstanding lawyers, lived at the Mansion House. John C. Calhoun, South Carolina's great antebellum statesman and author of the *Exposition and Protest*, a statement of the doctrine of nullification, always stayed there, according to Henry Bacot McKoy, preferring room number ninety-two.

In 1830, Dr. John Crittenden, the father of Stephen Stanley Crittenden, owner of a rival establishment, the Greenville Hotel, purchased the Mansion House for $10,000. In 1814, Crittenden, a prominent Greenville merchant and farmer and one of the original vestrymen for Christ Episcopal Church, had purchased one acre on the corner in front of the Mansion House for $1,000. Crittenden combined the two hotels and within five years had recouped his investment. In 1835, Crittenden sold the Mansion House to John T. Coleman for $10,500.

The Mansion House had many illustrious guests and played a part in significant events of the times. For example, in 1856, after the infamous caning of United States senator Charles Sumner by United States representative

Preston Brooks of Edgefield, Greenville fêted Brooks. Brooks contended that Sumner's "Bleeding Kansas" speech in the United States Senate had insulted his kinsman, Senator A.C. Butler of Edgefield. To defend the family honor, as Sumner was not considered his social equal, rather than challenge him to a duel, Brooks, accompanied by another South Carolina congressman, entered the United States Senate chamber and caned Sumner as he sat at his desk until he fell senseless to the floor. In the South, Brooks was a hero, and in the North, Sumner was a martyr. In Brooks's honor, there was a ball at the courthouse and a dinner at the Mansion House. In the immediate post–Civil War years, Brevet Major John William DeForest, the head of the Freedmen's Bureau for the Greenville, Pickens and Anderson District from 1866 to 1867, made the Mansion House his headquarters. DeForest wrote that Greenville was "the third town in South Carolina" in wealth and population; that it had a new courthouse and "one of the best country hotels" in the southern states. Yet he marveled that the proprietor of the Mansion House could provide a substantial breakfast (steak, bacon, eggs and hominy), dinner and tea with only five permanent guests.

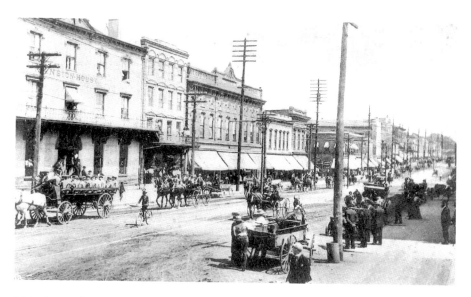

Main Street, Greenville, with the Mansion House on the left. *Postcards, gree. co. 126. Courtesy of South Caroliniana Library, University of South Carolina, Columbia.*

Despite the accolades, the war affected the hotel and its clientele. There were fewer guests in the post-1865 South to appreciate the joys of the Mansion House. In September 1876, during the gubernatorial campaign to oust Radical Republican government, General Wade Hampton, noted Civil War hero and Democratic candidate for governor, and his entourage visited Greenville. A mounted escort met the Hampton party at the train station and escorted them to the Mansion House, where they were staying.

During the 1880s, business revived and the hotel was refurbished. In 1886, Albion A. Gates remodeled the hotel, adding steam heat, electricity, fire alarms and water. In addition to Hampton, governor and later United States senator Benjamin Ryan Tillman, famous as the "one-eyed plowboy," and his wife preferred the amenities of the Mansion House. The unexpected death knell for the fabled hotel was the Spanish-American War. The War Department not only established Camp Wetherhill, a troop training facility in Greenville, but also designated the Mansion House as division headquarters from 1897 to 1899. The Mansion House never recovered from this interruption in its normal business, and in 1924, a contract was let for its demolition. In its place, new investors erected the Poinsett Hotel. Toney's grand dream lasted a century.

Less affluent visitors, such as the drovers with their herds of livestock, sought accommodations at the Kentucky and Tennessee Inn on Main Street. According to *The Greenville Century Book*, David Henning, at one point sheriff of Greenville County, operated the aptly named Kentucky and Tennessee Inn. Kentucky, in particular, was a major source of the drovers who visited Greenville. The Kentucky drovers brought horses and hogs over the mountains for Carolina markets. On the road between Greenville and the North Carolina line, the drovers would stop at accommodations such as Ballengers Stand, Merrittsville Camp, Hodges Inn or the stand known as the "House of Entertainment" in 1832. Drovers also frequented campsites near stores and taverns. Travelers Rest, near the intersection of the Buncombe and Jones Gap Roads, had several of these campsites. Owners of campsites and inns changed over time. Drovers traveled both the Buncombe and Jones Gap Roads from North Carolina to South Carolina. Stories abound about drovers who lost some of their livestock or their lives and money at these stands and campsites along these north–south avenues of commerce.

Of Mansions and Boardinghouses

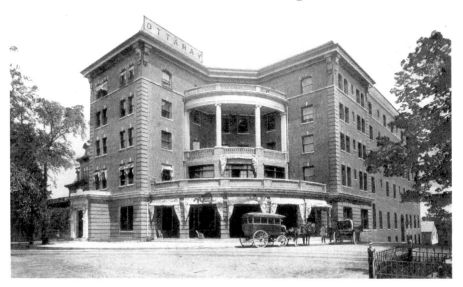

Ottaray Hotel, Main Street, Greenville. *Postcards, gree. co. 47 Courtesy of the South Caroliniana Library, University of South Carolina, Columbia.*

Stephen Stanley Crittenden operated one of the more famous of the Travelers Rest establishments. Major Henry Lynch had purchased 120 acres from the son of Revolutionary heroine Dicey Langston Springfield. Lynch built a store and inn, named Travelers Rest, to meet the needs of travelers. Eventually, Crittenden, Lynch's son-in-law, assumed control of the inn. Crittenden was also postmaster of Travelers Rest and the author of *The Greenville Century Book*, published in 1903.

Other Greenville hotels included the Goodlett House. In 1858, Robert P. Goodlett, the proprietor, advertised that his hotel had fifty rooms available for guests. In 1860, the forty-nine-year-old Goodlett was one of at least three hotel keepers in downtown Greenville. The other hotel keepers were the German-born Simon Swandale and E.F. Latimer. Goodlett's clientele in October 1860 included a dentist, a clerk, an artist, two merchants and two students. Most teachers and students chose boardinghouses like those operated by Anne E. Anderson or the Howards.

Greenville residents, such as Benjamin F. Perry, sometimes took a jaundiced view of the summer visitors. In 1836, Perry noted that while there were many visitors, there were few who "would interest a man of sense and

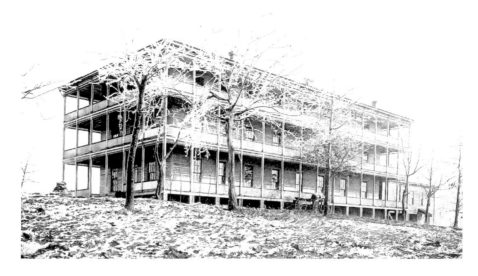

Hotel Altamont, summit of Paris Mountain, 1895. The Mountain House was the first hotel on Paris Mountain. Art Work Scenes in South Carolina. *Courtesy of the South Caroliniana Library, University of South Carolina, Columbia.*

reading." To him, it seemed that most visitors were only interested in drinking, womanizing, gambling and eating. The summer visitor mix included all of the expected stereotypes—eccentrics, bores, gossips and Don Juans. For example, Benjamin Allston of Waccamaw spoke with a heavy Lowcountry accent and loved playing whist, and Major Warley was known for moving his chair up one side of the street and down the other to follow the shade.

Outside of the town of Greenville, antebellum visitors had a number of choices. Dr. J.P. Hillhouse, known as a kind and attentive host, operated the Mountain House of Paris Mountain. In 1855, the Mountain House was known for its plain but comfortable accommodations and simple but abundant food. In 1852, Hillhouse petitioned the South Carolina legislature to build a turnpike from Buncombe Road to Paris Mountain. In December 1855, the South Carolina legislature authorized Hillhouse to construct, at his own expense, a toll road that would connect the Greenville Courthouse on the Buncombe Road with the Mountain House on or near the crest of Paris Mountain. Hillhouse, a graduate of the Medical College of Augusta, also served in the South Carolina legislature. In 1893, the Mountain House (also known as the Paris Mountain Hotel),

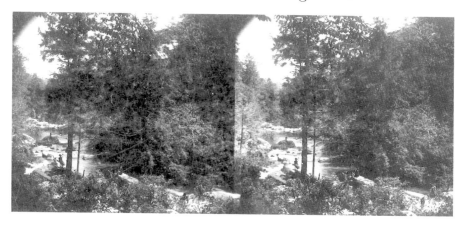

Little River Gorge, Caesar's Head. *Stereograph by A.F. Baker. Courtesy of the South Caroliniana Library, University of South Carolina, Columbia.*

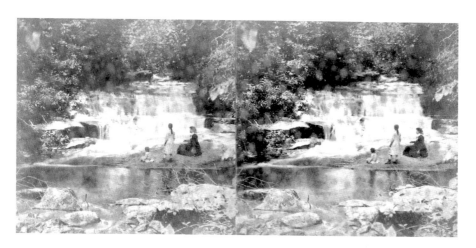

Silver Steps near Caesar's Head. *Stereograph by J.S. Broadway. Courtesy of the South Caroliniana Library, University of South Carolina, Columbia.*

with its twenty-two bedrooms, outbuildings, furnishings and 125 acres, was for sale.

Colonel Benjamin Hagood, a former state senator (1840–41) from Pendleton District, had a hotel at Caesar's Head on the Jones Gap Road. Hagood had originally chosen the spot as a family summer home. The Caesar's Head hotel, which could accommodate about forty guests, featured

spectacular views and fine food. In Hagood's will, dated July 23, 1852, he bequeathed the Caesar's Head property, roughly 480 acres, with all improvements and furnishings, to his second daughter, Elmina E. Hagood. The Blythe's Gap Turnpike provided access to Caesar's Head. After her father's death, Elmina Hagood Miles and her husband, Dr. F.A. Miles, operated the hotel for many years.

At Travelers Rest, in addition to the campsites for drovers, Cheves Montgomery opened an inn in 1851. In the 1870s, Colonel Robert Anderson purchased the Montgomery House, moved it and operated the establishment as the Spring Park Inn.

In addition to hotels in Greenville and hotels with mountain views, Greenville County was also home to one of the region's most visited springs. Chick Springs, about ten miles northeast of the county seat, was a major attraction. Dr. Burrell Chick investigated the springs' water and then purchased the site. His hotel opened in 1840. The hotel was so successful that some visitors built cabins in the area. According to Michael Tuomey's *Report on the Geology of South Carolina* (published in 1848), the waters of Chick Springs contained lime and magnesia salts. Among the springs' illustrious visitors was Governor John L. Manning in 1833.

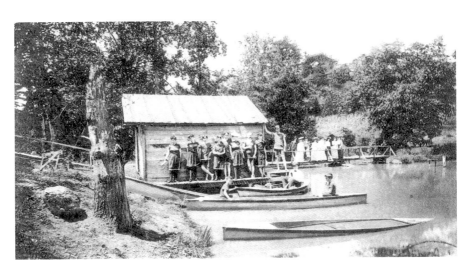

Chick Springs. Swimming was a popular pastime at Chick Springs. *Postcards, gree. co. 11. Courtesy of the South Caroliniana Library, University of South Carolina, Columbia.*

Of Mansions and Boardinghouses

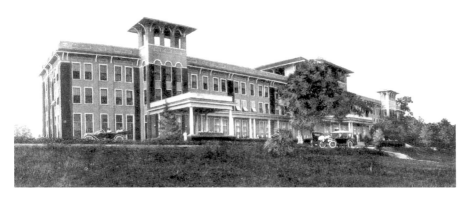

The New Chick Springs Hotel. Due to the popularity of the resort, facilities were upgraded several times. *Postcards, gree. co. 13. Courtesy of the South Caroliniana Library, University of South Carolina, Columbia.*

After Dr. Chick's death in 1847, his sons, Reuben S. and Pettus W. Chick, bought the hotel. Reuben and his wife operated the resort. In August 1854, the hotel had 150 guests. By 1856, perhaps seeking to reach a different demographic, Reuben and Pettus Chick had expanded the Chick Springs entertainment options to include ten-pin bowling and billiards. The shift to enhanced entertainment options reflected a reduced demand for the medicinal, healing qualities of the spring. The Chicks sold the hotel in 1857, and by 1858, John T. Hennery was operating Chick Springs. At that time, the advertised rates were $1.25 per day per person (children and servants, half fare) and $0.62½ per day, per horse. During World War I, the proprietors of Chick Springs attempted to capitalize on its proximity to Camp Wadsworth in Spartanburg County and Camp Sevier in Greenville County by offering special rates for those visiting the camps.

The Civil War ended the great summer migrations of Lowcountry Carolina planters and the great drover drives, yet visitors still came for the weather, the scenery, the food and the accommodations. By 1930, for example, Greenville had four large hotels—the Imperial, West Washington; the Ottaray, North Main; the Poinsett, South Main; and the Virginia, West Coffee—in addition to a number of smaller hotels, apartments and boardinghouses. Greenville continues to be a destination.

Murder, All in the Family

William Lowndes Yancey and Thomas Edwin Ware

The antebellum years were years of conflict. Unionists opposed nullifiers and secessionists, and rival newspapers feuded for the hearts and minds of the citizenry. Honor was never far from a Southerner's heart. In Greenville, honor and politics could be a deadly mix. For example, in 1832 rival newspapers and their editors clashed over secession.

Given the antebellum culture of personal honor, it is perhaps not surprising that two of the more sensational murder trials in pre–Civil War Greenville concerned alleged affairs of honor. The men accused of murder were respected members of society—men who were elected to state office. One was a lawyer, newspaper editor, state legislator and member of the United States Congress; the other was a planter and member of the South Carolina House of Representatives and Senate. Both married well, both killed relatives (at least by marriage) and both claimed self defense. Although convicted, due to their political connections, both had their sentences commuted or otherwise reduced.

The men in question were the high-handed William Lowndes Yancey, a quick-tempered anti-nullifier turned secessionist, and Thomas Edwin Ware. Yancey killed his wife's uncle; Ware killed his father-in-law. Both contended that their adversaries were larger, although older, men who struck them first. Neither of the murder victims, however, carried a firearm.

William Lowndes Yancey, born in 1814 in Warren County, Georgia, studied law with Benjamin F. Perry. Perry was a leading unionist and opposed nullification. In 1833, Yancey shared Perry's views on nullification.

Ben Yancey, the young son of William L. Yancey, was buried at the Earle Family Cemetery, Greenville. *Courtesy of Terry L. Helsley.*

In December 1834, Yancey became editor of the *Greenville Mountaineer*. The following year, he married Sarah Carolina Earle, daughter of George Washington Earle. Contemporaries described Yancey as five feet, seven inches tall, portly, with a high forehead and blue eyes. Following his marriage, Yancey began planting Earle family land with the labor of thirty-five slaves. In 1836, Yancey followed his cotton-planting dream to Alabama. Yet the family continued to visit Greenville. In Alabama, Yancey was a planter and newspaper editor. During one Greenville visit, Ben, Yancey's seven-month-old son and the namesake of his brother Ben, died. Young Ben Yancey was buried at the Earle Family Cemetery on Old Buncombe Road.

On September 4, 1838, while visiting a militia muster where congressional candidates Waddy Thompson and Joseph Whitner of Anderson were debating, Yancey denigrated Thompson's character and called him a "blackguard," as he had sided with the nullifiers. Thompson, who had been in the South Carolina House of Representatives from 1826 to 1829, served in the United States Congress from 1835 to 1841. At that time, Yancey had not yet experienced his conversion to secessionism. Seventeen-year-old

Murder, All in the Family

Elias Earle overheard Yancey's comments. Young Earle was a nephew of Thompson's and Sarah Earle Yancey's first cousin. Earle called Yancey "a liar," and Yancey slapped him. Earle then hit Yancey with his riding whip and called him a "damned liar." The next day, Yancey visited Dr. Robinson Earle, father of Elias Earle, to explain the incident.

Despite Yancey's efforts at conciliation, his version of the story differed from that of young Elias Earle. Also, a rumor began to circulate that young Earle had apologized to Yancey. Yancey, as was his habit as a resident of the wild Alabama frontier, was armed with a pistol, knife and sword stick when, on September 8, 1858, he met Dr. Earle at a tavern in Greenville. Yancey and his supporters contended that Earle's wife had urged him to address the insult to their son. At the time, Dr. Earle was sixty-two years of age and weighed 225 pounds. He carried a heavy walking stick and a small knife. When the two met, they left the tavern and, apparently in conversation, began to walk toward a store. Dr. Earle might have been armed for a fight, but he did not carry a gun.

Dr. Earle called Yancey a "damned liar." Yancey then drew his pistol and said, "Now call that back or take a shot." In the ensuing scuffle, Dr. Earle struck Yancey with the heavy walking stick he carried, and then Yancey shot him with the pistol he held in his right hand. When Earle did not immediately collapse, Yancey beat the wounded man with the empty pistol until the pistol broke. Afterward, still drawing blood with every blow, Yancey attempted to run Earle through with his sword stick. Onlookers eventually separated the men, and Dr. Robinson Earle died that night. According to his death notice, Dr. Earle left behind a wife and ten children.

On September 8, 1838 (the same day that Dr. Earle was buried), Yancey wrote to his brother Ben C. Yancey in Cahaba, Alabama, apprising him of Yancey's legal difficulties and presenting his side of the affair. In his comments to his brother, Yancey stated that he had done his "duty as a man and he who grossly insulted me lies" dead and buried nearby. He concluded with the observation that "the blood of the only man who ever called me 'a d___d liar' is now unwashed upon your stick," where he intended it to stay as "a legacy" for his son and a "warning to others who feel like browbeating a Yancey."

Benjamin F. Perry (Greenville), David L. Wardlaw (Edgefield) and Armistead Burt (Abbeville) defended Yancey against a charge of felony

murder. Yancey had worked with Perry. Benjamin Franklin Perry, attorney, unionist and newspaper editor, was born on November 20, 1805, in Old Pendleton District. Like Elias Earle, he was a son of the frontier, but one with family roots in Virginia and Massachusetts.

BENJAMIN F. PERRY

In 1823, Benjamin F. Perry came to Greenville to attend the male academy. Highlights of student life included trips to Paris Mountain and Table Rock. In 1831, Perry was the guest speaker for the annual Fourth of July celebration in Greenville. As editor of the *Greenville Mountaineer*, Perry opposed nullification. As a young man, so ardent was his devotion to the Union that his passions got the best of him. In 1832, he fatally wounded a rival newspaper editor— Turner Bynum—in a duel. Although he left the *Greenville Mountaineer* in 1833, Perry returned to the newspaper business with the anti-secessionist *Southern Patriot* in 1850. In 1837, following his election to the South Carolina House of Representatives, he married Elizabeth McCall of Charleston.

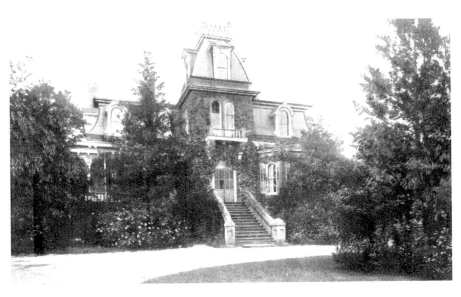

Sans Souci Country Club, once the home of Benjamin R. Perry, who defended William Yancey and Thomas Ware. *Southern Postcard Co., Asheville, North Carolina. Courtesy of William E. Benton.*

A delegate to the April 1860 Democratic Convention in Charleston, Perry refused to desert the party when agreement could not be reached on the issue of slavery in the territories: "It was as a Democrat and a Union man that I came into this Convention." Although a unionist and supporter of the Constitution, Perry was not an abolitionist. According to some sources, he was the only public voice in South Carolina who did not equate Lincoln's election with secession. Perry continued to oppose secession until South Carolina formally seceded. At that point, his devotion to his home state took precedence, and Perry enlisted in Confederate service. He served in the home guard, and later Confederate president Jefferson Davis appointed him a judge.

On June 30, 1865, President Andrew Johnson appointed Perry provisional governor of South Carolina. As governor, he reluctantly supported the Thirteenth Amendment but opposed the Fourteenth Amendment. He resigned that position to serve in the United States Senate. Unfortunately, Radical Republicans refused to seat him.

At heart, Perry was a political reformer. He supported the popular election of the governor and the abolishment of a property test to hold political office and also championed diversified industry, railroad expansion and public schools. Perry continued to be active in political life. In 1869, he supported construction of the Greenville–Charlotte railroad, and in 1876, he joined James C. Furman in supporting Wade Hampton's election and the return of white rule to South Carolina. When Hampton paid a campaign visit to Greenville in September 1876, Perry rode in his carriage. On October 12, 1870, he was one of the speakers for a special service honoring General Robert E. Lee.

Perry died on December 3, 1886. He and his wife are buried at the churchyard of Christ Episcopal Church.

Armistead Burt

Armistead Burt, son of Francis Burt and Catherine Miles, was born on November 13, 1802, at Clouds Creek near Edgefield. About 1820, he moved with his parents from Edgefield District to Pendleton District. There, Burt

studied at the Pendleton Academy. Following his preparatory education, he read law in the office of Warren R. Davis and was admitted to the South Carolina Bar in 1823. He began the practice of law in Pendleton. He married Martha Catherine Calhoun, daughter of William Calhoun and niece of John C. Calhoun, on March 12, 1827. They had no children.

In 1828, Armistead Burt moved to Abbeville, where he continued to practice law, formed a partnership with Nathan Lipscomb Griffin of Edgefield and engaged in agriculture. In 1832, he was a delegate to the Nullification Convention. Burt represented Abbeville District in the South Carolina House of Representatives. In 1835, Burt was a commissioner to receive subscriptions at Abbeville for stock in a bank at Hamburg, and in 1839, he was an incorporator of Abbeville Mineral Spring Company. Burt also owned property in Cashiers Valley, North Carolina.

Burt, representing the Fifth Congressional District, served in the Twenty-eighth through the Thirty-second United States Congresses (March 4, 1843–March 3, 1853). In August 1848, at the urging of John C. Calhoun, Burt introduced an amendment to the Oregon Bill that would have continued the 36° 30' line of the Missouri Compromise to the Pacific Ocean, making territories north of the line free-soil and territories south of the line, including those acquired from Mexico, slave. According to Milledge L. Bonham Jr., Burt was "not at his best as congressman," and an intimate of Burt's commented that as a congressman Burt "was a lawyer, not a statesman."

Burt returned to Abbeville, practiced law and lived the life of a planter, cultivating several Savannah River plantations, including Orange Hill. He continued his interest in preserving South Carolina's rights and in promoting the expansion of slavery in the territories. In 1856, Burt was chair of a joint committee that raised money and recruited men from Abbeville to relocate to Kansas. In 1860, the fifty-seven-year-old Burt owned $20,000 worth of real property and personal property, including fifty-four slaves valued at $50,000. He supported states' rights and secession, and on January 11, 1861, as commissioner from the "Republic of South Carolina," he visited the Mississippi Secession Convention to invite it to send delegates to Montgomery the following February to organize a Confederate government. In his address to the convention, Burt stated that South Carolina had seceded because the Republican Party planned "to uproot our institutions, and desolate the Southern country."

Murder, All in the Family

In 1862, Burt acquired the Burt-Starke Mansion in Abbeville, South Carolina. He was a close friend of Jefferson Davis, president of the Confederacy. On May 2, 1865, Davis and members of this cabinet, fleeing federal troops following the fall of Richmond, visited Armistead Burt at his home in Abbeville. There, Davis held his last council of war and decided not to pursue the war.

Following the Civil War, Burt and David L. Wardlaw drew up South Carolina's Black Code. Armistead Burt died on October 30, 1883, in Abbeville and was buried at Trinity Episcopal Cemetery.

David Lewis Wardlaw (1799–1893) was a respected legal mind, and by 1847, he had obtained a judgeship. In 1837, he was Speaker of the South Carolina House of Representatives. He was also a delegate to the Secession Convention and to the State Constitutional Convention of 1865.

With his high-powered defense team of Perry, Burt and Wardlaw, Yancey was prepared for his trial. The trial began on October 24, 1838, and lasted a grueling seventeen hours. At 2:00 a.m., the ordeal ended and the jury returned a verdict of manslaughter. The judge sentenced him to one year in jail and fined him $1,500. Yancey did not serve his full sentence, as Governor Patrick Noble commuted his jail time and returned two-thirds of his fine.

Yancey returned to Alabama and embarked on an active political career. In 1841, voters sent him to the Alabama House of Representatives. In 1843, he became a state senator, and in 1844, he was elected as a Democrat to the United States House of Representatives. He served in the U.S. Congress until 1846, when he resigned his seat. By the 1840s, Yancey was a fire-eater advocating secession. During his term in the U.S. Congress, he fought a duel with another congressman, Thomas L. Clingman of North Carolina. The duel was the result of a proposal to extend slavery to Texas. Both fired and missed and, in the presence of police and friends, agreed to settle their differences.

Affairs of honor seemed to follow Yancey. His biographer, Eric H. Walther, observed that Yancey seemed "determined personally to purge the South of people he considered dishonorable." In 1849, during a visit to Greenville, Yancey's wife became embroiled in a domestic dispute between her sister, Nancy Earle Stone, and Nancy's husband, Dr. C.S. Stone. Yancey considered

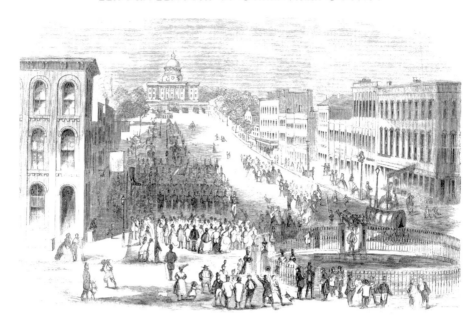

Statehouse, Montgomery, Alabama, 1861. *Courtesy of the Library of Congress.*

Stone a narrow-minded "domestic tyrant" who abused his wife. During the visit, Stone abused his wife and her mother in the presence of Sarah Yancey. Sarah stood up for her sister and mother, and Dr. Stone condemned her and the Earle family for meddling in his affairs. Following that encounter, Stone sent a note to Yancey demanding satisfaction. Yancey did not reply. During that same visit, Yancey almost became involved with Elias Earle, son of Dr. Robinson Earle, who wanted revenge for the death of his father. At times, it seemed that trouble dogged Yancey's steps.

William L. Yancey was also a delegate to the 1848, 1856 and 1860 Democratic Conventions. His presence at the 1860 Democratic Convention was fateful for the Union. Yancey clashed with Stephen A. Douglas over the Democratic Party platform, wanting a plank that guaranteed the extension of slavery into the former Mexican territories. When the convention adopted a more moderate position, Yancey led the delegates from five Southern states out of the convention. Ironically, the only South Carolina delegate who did not follow Yancey was Benjamin F. Perry, Yancey's defense attorney and a unionist. The Yancey walkout split the Democratic Party into Southern and

Murder, All in the Family

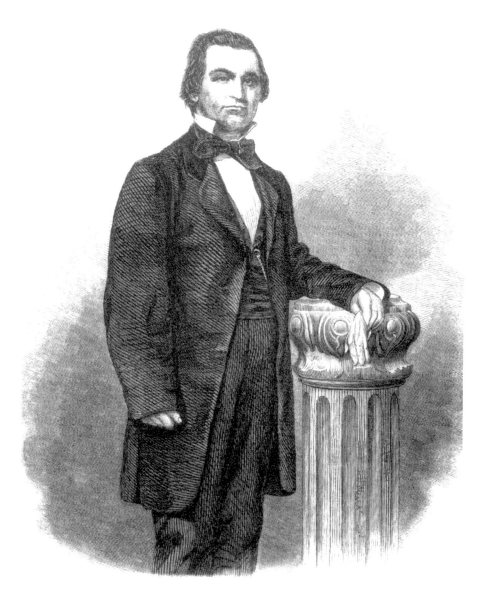

William Lowndes Yancey, 1860. *Courtesy of the Library of Congress.*

Northern parties. As a consequence, in the 1860 election, there were two Democratic candidates (Stephen A. Douglas and William C. Breckinridge), one independent candidate (John Bell Hood) and the Republican candidate (Abraham Lincoln).

With Lincoln's election and South Carolina's secession, the other lower South states (Georgia, Florida, Alabama, Mississippi, Louisiana and Texas) followed suit. Yancey was a member of the Alabama state constitutional convention in 1861 and was elected to the first Confederate States of America Congress. Yet he did not live to see the outcome of the events he helped set in motion, as he died on July 27, 1863, at his plantation near Montgomery, Alabama.

THOMAS EDWIN WARE

The other well-connected murder involved Thomas E. Ware. Thomas Edwin Ware, born in 1806 in Abbeville District, South Carolina, married an heiress, Mary Williams Jones, in 1834. Mary Jones was the only child of Adam and Jane Jones of Greenville. In time, the Wares moved to Greenville and lived on the Jones plantation, later known as Ware Place, on Augusta Road. Ware entered public life and served in the South Carolina House of Representatives from 1840 to 1847. In 1848, he began his tenure in the South Carolina Senate, where he served until 1864. On the 1850 census, the Jones and Ware households were enumerated side by side. At that time, Thomas E. Ware was a forty-four-year-old planter who owned twenty-nine slaves and had real property valued at $8,000. He and his wife Mary were the parents of a large family: Pauline (fourteen), James (twelve), Louisa (ten), Edmund (six), Albert (four) and Baby (two). Ware's in-laws, the Joneses, held twenty slaves and possessed real estate worth $7,000. In 1850, Adam Jones was fifty-five and his wife, Jane, was fifty.

Relations between the Wares and Mr. Jones began to unravel in 1851, when Mrs. Jones died. Adam Jones, the widower, was not content to live out his days under the watchful care of his daughter and son-in-law. Rather, a vigorous man, he began keeping company with eligible women and even found one he intended to marry. His pending remarriage became a point of

Tombstone of Mary Williams Ware, Ware Place Cemetery, Simpsonville. *Courtesy of Terry L. Helsley.*

contention between Jones and his daughter. After a number of acrimonious discussions, Jones demanded that the Wares move out of the house.

Before that eventuality came to pass, there was a fateful conflict between Jones and his son-in-law. The sixty-four-year-old Jones had been drinking heavily. The two men argued, and according to Ware, as he was leaving the room, Jones struck him with a "pair of fire tongs." In return, Ware shot the large, unarmed man, who died instantly. On February 16, 1853, the sheriff of Greenville County had Ware, a state senator, arrested for the murder of Adam Jones.

During Ware's trial, on April 14, 1853, Benjamin F. Perry (a member of the South Carolina House of Representatives) defended Ware as he had Yancey earlier. Despite his prominent defense attorney, the jury found Ware guilty of murder and ordered him imprisoned in the county jail. Nevertheless, Ware's jail time was short. A week later, Governor John L. Manning pardoned Ware

Memorial stone for Thomas E. and Mary Ware, Ware Place Cemetery, Simpsonville. *Courtesy of Terry L. Helsley.*

but imposed a $500 fine. From published cemetery records, the tombstone of Adam Jones bore the inscription, "Forgive us, O Lord." One wonders whether Colonel Ware or his wife was responsible for the wording.

Aside from the fine, Jones's murder had little impact on the Wares. Mary Jones Ware inherited, and in 1854, the Wares built an elegant home on Pendleton Road on a hill overlooking Greenville. According to the 1860 census, Ware owned real estate valued at $70,000 and personal property, including 102 slaves, worth $90,000. One of Greenville's wealthiest residents, Ware was the only person in the district to own over 100 slaves in 1860.

Yancey and Ware were only two of the colorful men and women who populated antebellum Greenville. These cases illustrate that "gentlemen" could be quick of tongue and trigger and that violent acts did not disqualify a man from public office.

"Capital" Greenville

1865

At one time in the fateful spring of 1865, Greenville was the temporary "capital" of South Carolina. The story began with General William Tecumseh Sherman's famous March to the Sea. Sherman marched his men through Atlanta to Savannah and then, in January 1865, turned north into the cradle of secession, South Carolina. With only two exceptions—Rivers Bridge and Aiken—the Union army rolled almost unimpeded across the state, leaving behind a swath of destruction forty miles wide. By February 16, it was knocking on Columbia's door, shelling the city from the site of the Saluda Manufacturing Mill. General Wade Hampton withdrew his troops on the morning of February 17, 1865.

Midmorning on the seventeenth, Intendant (mayor) Thomas J. Goodwyn and several city councilmen surrendered Columbia, the capital city of South Carolina, to Federal troops commanded by Colonel George Stone. That night, devastating fires burned a third of city and left as smoldering ruin a once thriving commercial district. Aware of the impending surrender, during the night of February 16, South Carolina's governor, Andrew G. Magrath, and other statewide officeholders fled the doomed city.

Andrew G. Magrath

Magrath was South Carolina's third and last Confederate governor. He served from December 20, 1864, to May 25, 1865. Born in Charleston in

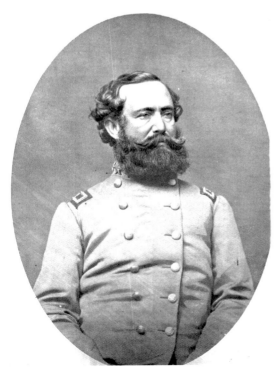

Above: New Statehouse, Columbia 1865. *Courtesy of the National Archives and Records Administration.*

Left: General Wade Hampton, CSA. The last Confederate commander to leave Columbia before Federal occupation. *Courtesy of the Library of Congress.*

1813, Magrath was the son of an Irish merchant. He graduated from South Carolina College, now the University of South Carolina, and studied law at Harvard. However, he also read law with James L. Petigru, prominent jurist and unionist, in Charleston. Admitted to the bar in 1835, Magrath also served in the South Carolina House of Representatives from 1838 to 1841. In 1856, he became a federal district court judge in Charleston. One of his more controversial rulings involved illegal efforts to import slaves into the United States. In 1860, Magrath ruled that ships seized with illegal slave cargo were not covered by piracy legislation. As piracy was a capital offense, the ruling was considered a victory for proslavery forces. As a result, individuals operating illegal slave ships could only be tried for a noncapital offense.

Later in the year, on November 7, 1860, following the election of Abraham Lincoln, Judge Magrath stunned and excited spectators in his courtroom when he dramatically removed his robe and, with great flourish, resigned his judgeship. To some, Magrath's resignation was the first step to secession. On November 27, 1860, Magrath addressed a secession meeting in the Greenville Courthouse. In January 1861, he wrote to J.W. Hayne, South Carolina's special agent sent to Washington, D.C., to negotiate with President James Buchanan for the return of Fort Sumter: "To shed their blood in defence [sic] of their rights, is a duty which the Citizens of the State of South Carolina fully recognize."

In 1862, Andrew G. Magrath became a Confederate district judge. Then, in 1864, he became not only the last Confederate governor of South Carolina but also the last South Carolina governor elected by the state legislature. Many saw his election as a victory for the anti–Jefferson Davis faction in the state. In his December 19 inaugural address, according to Charles Cauthen, he warned of the dangers of abolition and encouraged South Carolinians to vigorously prosecute the war. He also took an extreme states' rights stance, stressing the need to defend South Carolina's "honor and independence" against incursions by the Confederate government.

When Magrath was uttering these brave, but perhaps unrealistic, words, General William Tecumseh Sherman was already in Georgia, and the famed March to the Sea was underway. During Magrath's brief tenure, he allied with other Confederate governors in criticizing the Davis government for

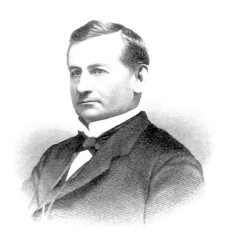

Andrew G. Magrath, South Carolina's last Confederate governor. *Courtesy of the South Caroliniana Library, University of South Carolina, Columbia.*

its trampling on the rights of the states and of individual Southerners. He contended that the Southern states had erred in acquiescing to demands of the central government and advocated unified state resistance to demands of the central Confederate government. Yet, on December 29, 1864, following General William T. Sherman's capture of Savannah on December 21, Magrath wrote Davis asking for additional Confederate troops to defend the endangered South Carolina lower districts. He wanted reinforcements for General P.G.T. Beauregard, who commanded Confederate forces in South Carolina. Davis did not have sufficient troops to fill the request. Magrath's attempt to negotiate a tri-state agreement for the sharing of militia also failed. Georgia refused to send state troops to assist South Carolina as South Carolina had earlier refused to aid Atlanta. So, South Carolina was left to its fate. In early January 1865, Governor Magrath issued a proclamation stating that any man who was not willing to fight to defend the state should leave. He advised those willing to fight to "remove all your property from reach of the enemy, carry what you can to a place of safety; then, quickly return to the field. What you cannot carry, destroy." Despite his brave words, the governor quietly evacuated Columbia when its surrender was inevitable.

Following the surrender and burning of Columbia in February 1865, a defiant Magrath attempted to rally disillusioned South Carolinians with

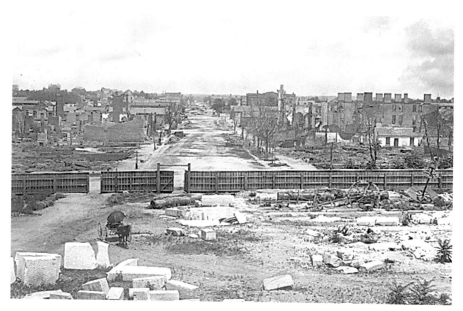

View from the Statehouse in Columbia after the city burned, 1865. *Courtesy of the National Archives and Records Administration.*

speeches and proclamations. Moving ever inland from the capital city, he established his headquarters first at Union and then in Spartanburg. In a last-ditch effort to reconstitute state government, he issued a proclamation calling for a special session of the South Carolina General Assembly to convene in Greenville on April 25.

Some state officials, such as William Richardson Huntt, the secretary of state, after he had removed ninety crates of state records in a railroad boxcar to Chester, joined the governor at the latter's headquarters in Spartanburg. There, Huntt, after learning of the "extra" session that the governor had called at the Greenville Courthouse, organized the official documents and supplies needed to perform his official duties and traveled to Greenville. In his 1865 petition to the legislature for reimbursement of his expenses, Huntt detailed nightmarish times in Greenville. He wrote of being stranded there for two weeks "for want of transportation." The delay placed Huntt in the Greenville area at the time of Stoneman's raid. Huntt stated that he encountered raiders near Greenville and was "captured and robbed

of his clothing." In addition, Huntt asserted that he lost his receipts and barely escaped with the seals of the state, which were in his possession at the time of the robbery. Once he was able to leave Greenville, Huntt took the records that he had transported to Greenville and returned with them first to Spartanburg and then to Columbia. His sister later wrote that Huntt, his wife and three small sons traveled to Columbia by boat on the Congaree. Perhaps in those unsettled times, river transport was more reliable than rail.

James A. Black, South Carolina's comptroller general, may also have attended the short-lived special session in Greenville. He later petitioned the legislature to reimburse his expenses of transporting the official records of the state treasurer and comptroller general from Greenville to Chester and then back to Columbia.

Greenville and Greenville County were unlikely targets for Magrath's regrouping effort. Until 1860, the area had a long unionist tradition. Benjamin F. Perry and others had opposed nullification and pre-1860 movements toward secession. Abandoning that position after Abraham Lincoln's election in November 1860, the residents of Greenville hastened to join the rest of South Carolina in secession. Greenville County raised three regiments for Confederate service. The State Military Works located in Greenville repaired firearms and produced high-quality arms and ammunition, including cannons, cannonballs, shells and breech-loading rifles. Furman suspended classes for the duration of the war, and Greenville's women organized auxiliaries and associations to furnish clothing and other necessities for the Confederate army and to care for the sick and wounded. After the Union occupation of Beaufort and the Sea Islands in 1861, refugees from the Carolina Lowcountry swelled the population of the South Carolina Midlands and Piedmont. Greenville became a place of safety/sanctuary.

Yet despite such overt proof of Confederate support, the Greenville area, especially upper Greenville, was home to a large population of deserters, draft dodgers and others critical of governmental activities under the Confederate States of America. Stories of home intrusions, robberies and armed conflict were common. Yet compared to the Lowcountry and Midlands, Greenville County was relatively unscathed by the Civil War.

The Greenville Courthouse, Magrath's choice for a legislative assembly site, was Greenville's third courthouse. Built in 1854–55, the Civil War–

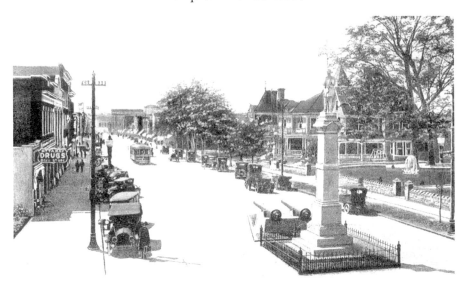

Main Street, Greenville, with the Confederate Monument, circa 1918. *Courtesy of William E. Benton.*

era courthouse stood on Main Street near the Mansion House. Its large, magnificent courtroom seated five hundred, which was more than adequate to house members of the South Carolina General Assembly. To prepare the site for another courthouse, workmen demolished the building in 1916–17.

Despite his best efforts, Governor Magrath's attempts to reconstitute state government failed. While several state officials were present, few legislators attended the special session. As a result, there were not enough present to constitute a quorum. Unable to transact official business, the governor addressed the assembly before it adjourned.

Magrath returned to Columbia and continued his efforts to assert his control in the state, despite Federal occupation. On May 2, he issued a proclamation that all Confederate supplies in the state should be turned over to special agents and used to assist returning Confederate veterans. An angry General William Gillmore, Federal commander in South Carolina, reprimanded Magrath and reminded him that the supplies in question were the property of the United States. On May 15, Gillmore issued General Order No. 63, warning all citizens that any "proclamations, commissions or commands" issued by the governors of South Carolina, Georgia and Florida, "unless promulgated by the advice and consent of the

United States authorities," are "null and void." The order also charged the offending governors with "acts of treason." In response, Magrath issued his last proclamation on May 22, 1865. In his final public word, the last Confederate governor of South Carolina stated, "The war is over." He also encouraged South Carolinians to "forbear opposition which is hopeless" and to submit to the unavoidable—that which "you cannot resist." On May 25, Federal troops arrested Magrath and took him by ambulance to Fort Pulaski. The arresting officer, according to the *New York Times*, was Lieutenant George C. Beech of the Third New York Artillery.

The failed special session in April may have been a harbinger of a shift in Greenville's fortunes. Its immunity to catastrophe disappeared as Stoneman's raid brought the destructiveness of war to the piedmont city. On May 2, 1865, Union cavalry, under the command of General George Stoneman, raided Greenville looking for Jefferson Davis. The Federal troops did not find Davis but did loot several establishments before withdrawing. The Union cavalry continued its pursuit through Anderson, South Carolina, and into Georgia. Although it often barely missed Davis, another Union outfit claimed the honor of capturing the president of the Confederacy in Irwin, Georgia.

After Magrath's arrest, he was briefly imprisoned at Fort Pulaski, in Savannah, Georgia. Released in December 1865, Andrew G. Magrath returned to his native Charleston and developed a successful and profitable legal practice. He died there in 1893.

Yet for a few weeks in 1865, Magrath tried to make order out of disorder and to cling to the past in the face of an inconceivable present. During those chaotic days, Greenville was briefly a place of hope—a last-ditch effort to stop South Carolina's descent from an independent state to an occupied one.

CHAPTER 7

"OVER THERE, OVER HERE"

Camp Sevier

The assassination of Archduke Franz Ferdinand on June 28, 1914, ended more than the Austro-Hungarian Empire. The Serbian quest for independence triggered the first great world war of the twentieth century. United States involvement in that conflict derailed the Progressive Movement. Instead of pursuing public health and vaccinations or building schools, libraries and parks, Americans geared up for the first great world war—the so-called War to End All Wars. The country's focus shifted to training men to be soldiers and producing the armaments needed for the war in Europe. America was ill-prepared for the conflict, and the War Department opened several cantonments (temporary troop quarters) in various parts of the country to train state guardsmen for overseas duty. Even before the formal declaration of war, Greenville's mayor and other civic leaders lobbied the War Department for a camp in Greenville. Camp Wetherill, a temporary training center located in Greenville during the Spanish-American War, had been an economic boon to the area. Greenville's bid was successful. In fact, South Carolina had three World War I training camps—Camp Sevier in Greenville, Camp Wadsworth in nearby Spartanburg County and Camp Jackson near Columbia in Richland County. The chosen site for the camp on U.S. 29 covered two thousand leased acres located slightly more than three miles from downtown Greenville. As an added advantage, two railroads crossed the property. Construction on the new camp began in July 1917. Major A.C.

Doyle of Columbia was the construction quartermaster for Camp Sevier. The new camp boasted the first paved road in Greenville County.

The first troop arrivals in July were companies from the First Regiment, South Carolina National Guard, formerly stationed in Columbia. By August 2, North Carolina guardsmen had also arrived, and on that date, the cantonment was officially designated Camp Sevier. Camp Sevier was named for John Sevier (1745–1815), Tennessee troop commander at the Battle of King's Mountain and later the first governor of Tennessee. The name was well chosen, as the camp was a temporary training site for nationalized national guardsmen primarily from the Carolinas, Georgia and Tennessee. Trainees drilled; honed their marksmanship; learned how to use machine guns, automatic rifles, mortars and bayonets; and practiced gas defense. Some trained as signal operatives or as artillerymen. By the end of August, Camp Sevier was home to thirty thousand soldiers.

Initially, camp trainees included "all former national guard units from Tennessee and all but 3 battalions from South Carolina." The Tennessee guardsmen traveled in four special trains of thirteen cars each and reached Camp Sevier on September 9, 1917. The Thirtieth Infantry Division, also

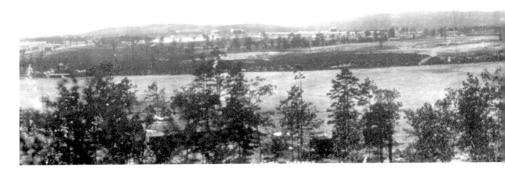

View from the Stockade Tower, Camp Sevier, 1918. *J.R. Peden, photographer. Courtesy of the Library of Congress.*

known as "Old Hickory" in honor of President Andrew Jackson, was the first division activated at Camp Sevier. It included guardsmen from Tennessee, North Carolina and South Carolina. This was a fitting geographic representation, as both Carolinas claimed to be Jackson's birthplace and Tennessee was his final home. After completing its training in May 1918, the highly-decorated Thirtieth Infantry Division served with the American Expeditionary Force under the command of General of the Armies John Joseph "Black Jack" Pershing. They served valorously in a number of major campaigns, including the Somme and Ypres in France and Belgium. Among the soldiers of the Thirtieth, there were twelve Medal of Honor recipients. Six of them were South Carolinians. After the Thirtieth Infantry Division deployed, the Eighty-first (Wildcat Division) and Twentieth Divisions also trained at Camp Sevier. The Eighty-first were at Camp Sevier from April to July 1918. By the time the war ended, between 100,000 and 150,000 men had trained at the camp.

Camp Sevier was a huge and dusty tent city. A soldier's life included long hours of drilling and training with occasional recreational opportunities. For recreation, Camp Sevier had a YMCA tent equipped with moving picture cameras, phonographs, religious and secular reading materials, writing

supplies (for letters home) and sporting equipment (baseball and football, for example). However, life at Camp Sevier was more than challenging and dull; it was also deadly. On November 16, 1917, Major L.D. Gasser, acting chief of staff for the Thirtieth Division, announced that the camp was quarantined, effective November 17. Calling the quarantine "purely a precautionary measure," Gasser cited a measles epidemic and several cases of pneumonia and meningitis. The announcement was an understatement. There were also cases of mumps and smallpox. The situation was so severe that at one time camp officials suspended training in the use of gas masks in an attempt to slow the spread of respiratory diseases.

Two days later, on November 18, 1917, Major General W.C. Gorgas, surgeon major of the army, cited overcrowded tents, poor or incomplete

1-2-3 Training Battalion, Fifty-fifth Depot Brigade, Camp Sevier, 1918. *J.R. Peden, photographer. Courtesy of the Library of Congress.*

hospital facilities, lack of winter clothing and lack of adequate quarantine facilities as contributing causes to the spread of disease in the training camps. Gorgas had inspected four army camps: Camp Bowie in Texas, Camp Funston in Kansas, Camp Doniphan in Oklahoma and Camp Sevier in South Carolina. The severe winter, with unusually high snowfalls even in the South, exacerbated the situation. For example, Camp Wadsworth in Spartanburg had recorded a thermometer reading of twelve degrees. Yet the soldiers lacked winter overcoats and were still wearing their summer khakis. Camp hospitals at Camp Sevier and other facilities were incomplete and lacked plumbing. In addition, Camp Sevier's hospital also lacked heat. Gorgas reported that, in the last month, besides other deaths, sixty men had died from pneumonia at Camp Sevier, and there was a measles epidemic at the camp.

From his inspection of Camp Sevier, Gorgas particularly noted the poor sanitary conditions. During the preceding month, the camp had 2,000 cases of measles, 175 cases of pneumonia (60 of which resulted in death) and 15 cases of meningitis. Most of the inductees, as they came from rural, sparsely populated areas, were not immune to measles. To Gorgas, the most glaring cause of the poor sanitation in the camp was overcrowding. Due to a shortage of tents, at one point, some tents housed eleven to twelve men at one time. Even with nine men in a tent, each one would only have about twenty-eight square feet of space. Gorgas recommended five as a good target number. Gorgas also recommended a quarantine area for all new arrivals so that those with contagious diseases could be identified and treated before the problem spread to others in the camp. The War Department acted on Gorgas's inspection report, and winter uniforms arrived quickly.

The men returned to training and eventually shipped out for Europe. In the spring of 1918, new troops were inbound. The 81st Division moved from Camp Jackson to Camp Sevier. In May, the first of several units of the 81st camped at Laurens en route. One of the weddings involving Camp Sevier personnel was the May wedding of Sarah Cain and Lieutenant Mortimer Cosby of the 322nd Infantry. The couple married at Washington Street Methodist Church in Columbia. The groomsmen were also army officers—Lieutenant Rufus Malloy of Camp Jackson and Lieutenants John Johnson, James Hardison, J.F. Carter and Joseph Jacobs of Camp Sevier. The organist announced the arrival of the wedding party by playing "The Star-Spangled Banner."

Also in May 1918, thirty-one-year-old Margaret W. Wilson, youngest daughter of President Woodrow Wilson, sang twice for the soldiers of Camp Sevier. As she then traveled to another military venue, perhaps this was the World War I version of a USO show. Margaret Woodrow Wilson (1886–1944) served as her father's official White House hostess until he remarried. In the decade prior to 1920, Wilson sang and recorded. A 1915 recording featured "The Star-Spangled Banner," and in 1917, during World War I, she recorded "My Old Kentucky Home" as a fundraiser for the American Red Cross. In 1938, Wilson moved to the ashram of Sri Aurobindo in Pondicherry, India. Renamed Nistha, she died there in 1944. A concert in July 1918 featured Ruby Gaston on the piano and Fredericka Scott, a soprano

"Over There, Over Here"

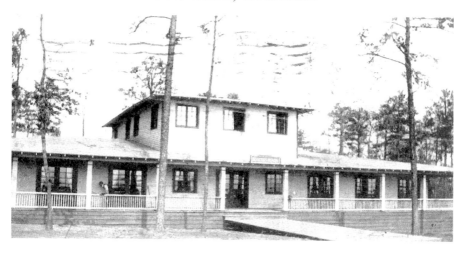

Hostess House, Camp Sevier. *Postcards, gree. co. 9. Courtesy of the South Caroliniana Library, University of South Carolina, Columbia.*

and harpist. Sponsored by the YMCA, Gaston and Scott had performed at Camp Jackson before traveling to Camp Sevier.

In addition to the YMCA, with four buildings at the camp and nightly screenings of movies, Camp Sevier had a Liberty Theatre that booked stage productions from the sublime—opera—to burlesque. The Red Cross, Knights of Columbus and the American Library Association all sponsored respites for the trainees. Chaplains held weekly religious services and taught classes. The City of Greenville also offered venues to entertain the soldiers, including dances and canteens. (Mrs. Duke sold her namesake mayonnaise to soldiers in these canteens, achieving renown for the product she would later sell to the C.F. Sauer Company.) Many Greenville residents entertained the troops in their homes.

A June highlight at the camp was an athletic contest between a Cherokee ball team of the 321st Infantry, 81st Division, and a Cherokee team from Western North Carolina. Cherokee ball was a long-practiced Native American tradition and the origin of the modern sport of lacrosse. Early Europeans encountered the sport and noted that such ball games were serious matters. Villages coveted good players, and wagers could be high. The Cherokees once won a town in Georgia from the Creeks. On June 15, a baseball team from Camp Sevier defeated a team from Camp Wadsworth.

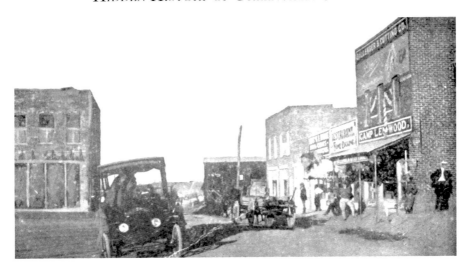

"Gay Paris," Sutlers Row, Camp Sevier. *Postcards, gree. co. 150. Courtesy of the South Caroliniana Library, University of South Carolina, Columbia.*

Soldiers with their Ford, 1918. *Photographs, 9603.10. Courtesy of the South Carolina Library, University of South Carolina, Columbia.*

The winning pitcher, "Whitey" Glazner, had played with the Birmingham Southern League Club. In July, W.L. Laval reported that the YMCA had sponsored 1,954 athletic events during the month of June. Over seven

thousand spectators enjoyed the games. Volleyball and baseball were the most popular activities with players and spectators.

On a different note, in July, army officials transferred one hundred German prisoners of war from Fort McPherson, Georgia, to Camp Sevier. Officials planned to use the Germans as labor for a two-hundred-acre farm developed by the reclamation division of the camp. Later in the month, Greenville residents were surprised to learn that one of the German prisoners, a man named G. Hahn, held in the stockade at Camp Sevier had escaped. The prisoner did not travel far, as authorities captured the prisoner at Easley and returned him to camp. According to published reports, Hahn was armed with knives and saw blades.

Also in July 1918, Fitzhugh Lee Brown became manager of the Liberty Theatre at the camp. Brown was a highly respected theatrical manager and had, for twenty-six years, managed the Columbia Theatre. He booked such productions/acts as Maude Adams, *Ben Hur*, Victor Hubert's Orchestra and the Metropolitan Orchestra. Brown also sponsored rail excursions from Charlotte, Charleston and Augusta to Columbia so patrons in those cities could see productions not available in their home venues.

However, in the fall of 1918, the national epidemic of Spanish influenza struck Greenville and Camp Sevier. On September 27, 1918, officials quarantined the camp. Soldiers were not allowed to visit Greenville, except on official business, and in addition, the order banned all indoor gatherings in the camp. However, worship services and stage shows could be held outside. Despite the flu outbreak, the army continued to ship additional soldiers to Camp Sevier. One thousand from the 156th Depot Brigade arrived from Camp Jackson the day the quarantine was announced. Despite the quarantine and soldiers being forced to remain outside, influenza spread from camp area to camp area virtually unchecked. The 220th Field Signal Battalion even sent a football team to play Clemson. The Clemson Tigers won the game, with a score of 61–0. The service team sent the message of its defeat back to Camp Sevier by carrier pigeon.

By the end of September there were over one thousand cases of influenza. Camp hospital facilities were filled to capacity and other facilities, including one of the YMCA huts, were drafted into service to house the patients. During the height of the outbreak in October, there were hundreds of new

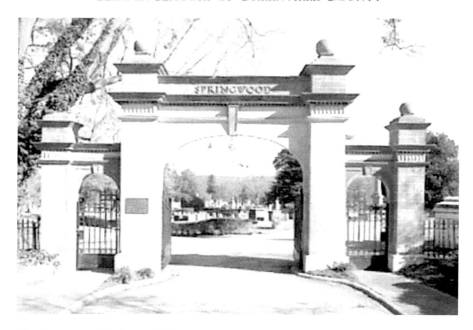

The front gate of Springwood Cemetery, Main and Elford Streets, Greenville. Over twenty of the men, including Fred Kirk, who died at Camp Sevier are buried in Springwood Cemetery. *Records of the National Register of Historic Places, Greenville County. Courtesy of the South Carolina Department of Archives and History.*

cases, and men died daily. According to Frances Withington, as quoted by Greenville historian Dr. A.V. Huff, "Caskets were stacked like cord wood" at the train station. At least twenty of the soldiers who died during the influenza epidemic are buried in a special plot in Springwood Cemetery, Greenville. The Greenville outbreak was part of the Spanish influenza pandemic that circled the globe between 1918 and 1920. An estimated 28 percent of the American population succumbed to the flu, and between 500,000 and 675,000 died. By the end of October 1918, officials at the camp had lifted the quarantine on indoor activities but continued to restrict contact between the soldiers of the camp and the residents of Greenville.

In addition to the difficulties identified in the Gorgas report and the outbreak of Spanish influenza, other catastrophes plagued Camp Sevier. On November 19, 1917, in addition to the deaths from pneumonia, William Dallard, according to the *State*, died from electrocution. He suffered an electric shock during signal practice. In May 1918, a wooden railroad car carrying

men from the 321st Infantry to Camp Sevier fell off a trestle near Camp Jackson in Richland County. Eight soldiers died and twenty-six were injured.

Captain Sayres Louise Milliken, chief nurse of the base hospital at Camp Sevier, was one of the World War I nurses awarded the Distinguished Medal of Service. Earlier, she was assigned to the occupying force at Vera Cruz, Mexico, during the expedition against Poncho Villa in 1916. In December 1918, Milliken became assistant superintendent of the Army Nurse Corps, Office of the Surgeon General, Washington, D.C. There, she helped lobby successfully for the passage of an act granting retirement pensions to army and navy nurses. In another context, Milliken wrote that nursing during World War I was a "harrowing but glorious adventure."

Troops from Indiana, Iowa and other states joined those from the Carolinas and Tennessee. Also, African American inductees from Washington, D.C., and South Carolina trained at Camp Sevier. Regular army units replaced the reorganized National Guard Units, and new recruits and draftees helped fill the depleted ranks. In May 1918, the camp's facilities expanded as workers completed a new two-oven bakery, three new fire stations and a black powder magazine. Despite this activity, the population of the camp fluctuated, and by January 1919, there were only seven thousand men stationed at Camp Sevier.

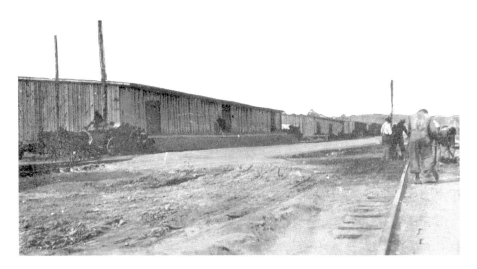

Quartermaster warehouse, Camp Sevier. *Postcards, gree. co. 47. Courtesy of the South Caroliniana Library, University of South Carolina, Columbia.*

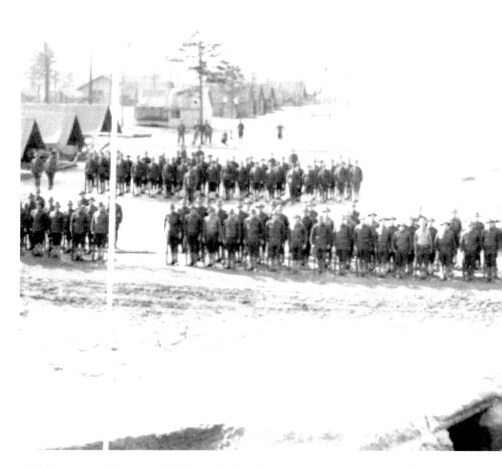

105th Engineers, March 7, 1918, Camp Sevier. *J.R. Peden, photographer. Courtesy of the Library of Congress.*

World War I ended on Armistice Day, November 11, 1918. Shortly thereafter, on December 3, Camp Sevier became a demobilization center for returning American troops. In May 1919, there were over three hundred patients in the hospital at Camp Sevier. Most had severe respiratory problems as a result

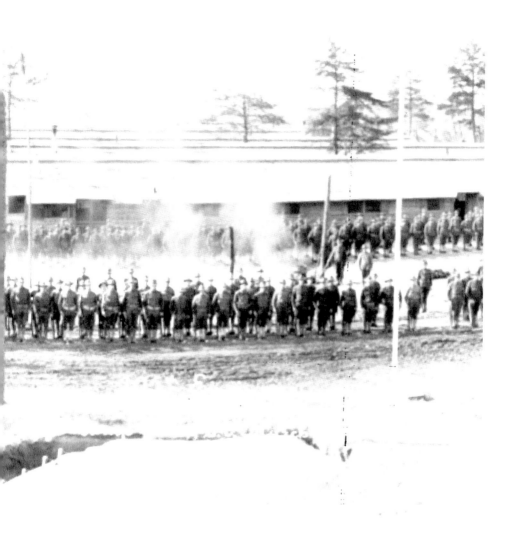

of being gassed in France. With the exception of the base hospital and the remount station, the camp looked deserted. In November 1919, with hospital consolidation, the number of patients at Camp Sevier increased to eight hundred. That same year, fire destroyed the officers' quarters of the United States public health service hospital at Camp Sevier. Camp Sevier's base hospital outlived the training camp. Until 1925, it was a tuberculosis hospital.

On April 8, 1919, Camp Sevier ceased to function as a training facility. In September 1919, the government was requesting sealed bids for 7,070¼ cords of wood located at Camp Sevier, and by October, Greenville leaders were working with United States Senator E.D. Smith to resolve claims against the government, particularly the War Department, related to Camp Sevier. With the aid of Senator N.B. Dial, W.G. Sirrine, attorney for the Greenville Chamber of Commerce, announced on November 19, 1919, that all claims concerning damages to land timber had been settled.

In January 1920, the Greenville American Legion Post announced plans to place tombstones at the more than one hundred unmarked graves in Greenville of men who had died at Camp Sevier. And so the curtain fell on another chapter in Greenville's long history.

THE FABLED DARK CORNER

Land of Contrast

The fabled Dark Corner has a special fascination. The name evokes a mindset and a way of life—forgotten and forbidden. Traditionally, the Dark Corner, located in the northeastern corner of the county, covers about 150 square miles and includes Glassy Mountain Township and environs. Although settlers moved into the area after the American Revolution, the area's remoteness produced a small population of independent, self-reliant individuals with a unique culture. Families were close-knit. Few roads connected the Dark Corner with the outside world. Exceptions included the State Road, which connected Columbia and Asheville, and the Howard's Gap Road. Given the terrain, bridges are vital in the Dark Corner, and it is home to two of Greenville's finest—the Poinsett Bridge, designed by Joel R. Poinsett, and the Campbell's Covered Bridge. Glassy and Hogback Mountains dominate the horizon. The cultural uniqueness of the Dark Corner persisted into the twentieth century. In the twenty-first century, new residents, new developments and greater access have altered older customs and lifestyles.

The origin of the name "Dark Corner" is debated. Some consider it reflective of the remoteness of the location. Benjamin Perry asserted that a disgruntled nullifier candidate coined the phrase in 1832. The unnamed individual used the phrase to denote a corner of Greenville County where the doctrine of nullification would never hold sway. Voters in the Dark Corner were loyal supporters of Perry, the anti-nullifier and unionist.

Glassy and Hogback Mountains in the Dark Corner are monadnocks. The Carolina piedmont has other examples, including Table Rock Mountain

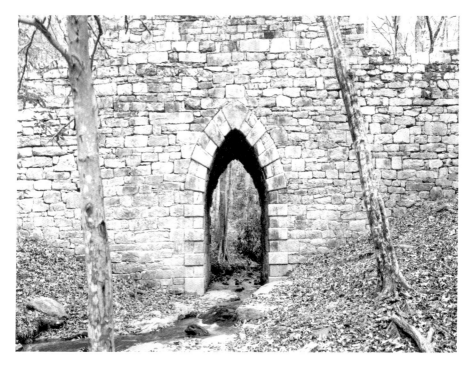

Poinsett Bridge, a Greenville County landmark, is the only surviving stone bridge in the county designed by Joel R. Poinsett. *Courtesy of the Library of Congress.*

in Pickens County, King's Mountain (site of the Revolutionary battle that turned the tide of war in the South) and Paris Mountain. These mountains are geologically and botanically rich. Composed of granite gneiss, they feature bare outcroppings, forests and streams.

Early residents built blockhouses, or forts, along the Cherokee line for safety. A well-known blockhouse stood at the junction of the Cherokee line with the North Carolina boundary. Place names such as Gowensville preserve the names of these early forts. Many of these sites evolved over time from protection to trading center to accommodating travelers. For example, by 1800, the blockhouse on Howard's Gap Road had become a campground for drovers. Men on horseback and in wagons stopped with their herds of livestock and flocks of turkeys. There were pens for the animals and indoor accommodations for stagecoach passengers and others.

The Fabled Dark Corner

Dark Corner inhabitants were staunch unionists during the antebellum years. These mountaineers did not join the rest of Greenville County in endorsing secession. Conscription was unpopular among Dark Corner residents. After the Civil War, a Mr. Looper, who lived in the vicinity, commented to J.W. DeForest that Confederate officials had to force enlistments at gun point. A widow shared her account of the day Confederate sympathizers chased and shot her husband as a deserter. Hearing gunfire, she ran from the house, and one of the men, a neighbor, told her, "Your old man is dead; we shot him for a deserter; you'll find him down there a piece!" The remoteness and difficult terrain of the Dark Corner made the area a refuge for draft evaders and deserters. The independence of the people made it a difficult area for Confederate officials, such as Major A.D. Ashemore, to enforce conscription. At first, few men in upper Greenville volunteered, as the area had a long tradition of unionism. Although Benjamin F. Perry spoke at county militia musters to encourage Confederate army enlistments, the results, especially in the Dark Corner, were negligible. Conscription efforts increased as the war dragged on, and agents even used bloodhounds to locate reluctant enlistees.

Stories abound of outliers, skulkers and draft evaders who found refuge there during the Civil War. At times, bands of organized deserters preyed on the citizens of Greenville County. Some retreated to blockhouses in the Dark Corner to escape capture. At one point, Major Ashemore requested a cannon to dislodge a gang from one of the blockhouses.

Isolated and independent people made the Dark Corner their home. Self-sufficiency was a byword for these mountain dwellers who adopted a "live and let live" attitude toward life. By the 1880s, most residents were subsistence farmers who produced food for their families with small plantings of market crops, such as corn, wheat and cotton. In general, the homes lacked conveniences, and life was hard. The proliferation of textile mills in the Upstate changed this situation. For the first time, residents had nonagricultural employment options.

There are many stories in this land of contrasts—great natural beauty and poverty; violent characters and saints like the Reverend A.D. Bowers, who preached the gospel in the Dark Corner for forty years without salary. Newspapers, generally, report only the most dramatic of tales. What follows

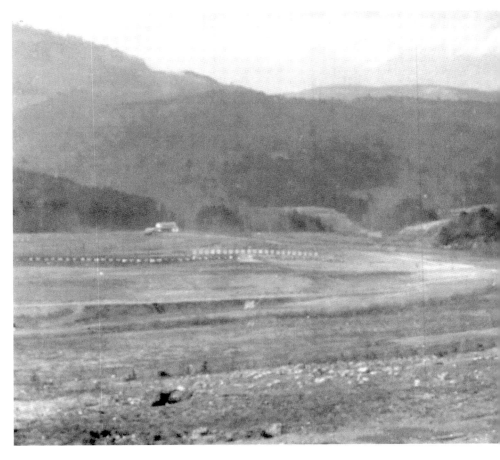

U.S. Rifle Range, Glassy Mountain, circa 1918, Camp Wadsworth, Spartanburg County. *H.M. Beach, photographer. Courtesy of the Library of Congress.*

are a few noteworthy examples that capture the flavor of those "dark days" as the nineteenth was turning into the twentieth century.

While the naming of the Dark Corner is disputed, much of the area's fascination rests on the dark days of illegal, untaxed alcohol manufacturing—moonshining. Distilling corn into whiskey was one of the few cash-earning possibilities open to Dark Corner residents. For example, at one point, a farmer could sell a bushel of corn for sixty cents, but if, instead, he distilled that bushel into three gallons of whiskey, he could sell the whiskey for one to two dollars per gallon. Economics

favored moonshining, so named because the mountain distillers pursuing an illegal trade had to work in secret. They distilled their product deep in the coves and hollows, hidden in thickets near streams. There was less chance of "interruptions" at night. Even before Prohibition (1920–33), whiskey distilling without a license violated federal law, and revenue agents raided deep in the Dark Corner or stopped wagons leaving the area. Today, distilling spirits without a commercial license is still illegal in the United States.

Even in the Dark Corner, there were a few government distillers, such as Benjamin A. Ross. In 1888, shortly after Ross testified concerning the wounding of Massena Howard, someone shot up his house, killing him.

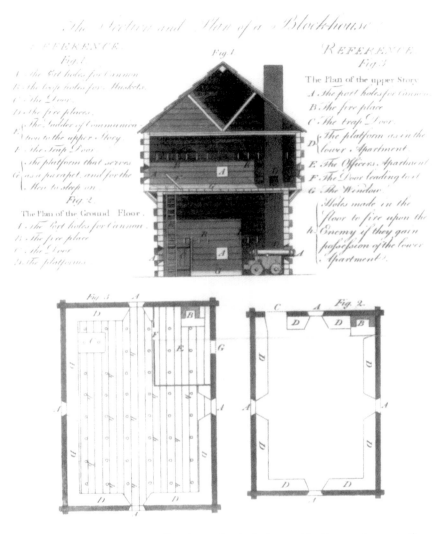

Plan of a blockhouse, circa 1789. Frontier settlers built forts or blockhouses for protection. A famous one stood at the junction of the Cherokee boundary and the North Carolina state line. *Courtesy of the Library of Congress.*

Ross lived near Gowensville. Big Bill and Little Bill Howard were accused of the crime. The jury acquitted Big Bill Howard but convicted Little Bill of the murder. Condemned to hang, William "Little Bill" Howard escaped from the Greenville County jail in October 1890.

Stirring mash, blockade still, 1897. *Photographs, M-PL-GV-1. Courtesy of the South Caroliniana Library, University of South Carolina, Columbia.*

The Howard escape was a classic case. Howard's wife arrived to visit one Saturday night. On Monday morning, the jailer released her, only to discover a short time later that he had released Howard instead. Howard had changed clothes with his wife and walked out of the jail carrying their baby. To avoid Howard's absence being noticed, Mary Howard had hidden under the covers. As a result, it appeared that Little Bill was in his bunk. After the discovery, the jailer released Mary Howard, and she recovered her baby. Sheriff Perry Duncan Gilreath captured Little Bill, and by February 1891, he was back in the Greenville jail. In a seemingly

never-ending trail of blood begetting blood, George Center, the nephew of Ben Ross's wife, in December 1890 killed William "Big Bill" Howard. In August 1891, the feuding Howards were involved in a gun battle at Mountain Hill Church, Glassy Mountain. At times, there were few places of sanctuary in the Dark Corner.

In 1894, Deputy Marshal Blaloc, while searching for a still, ran into an ambush. Luckily, the deputy was unharmed. Blalock, according to the published account, suspected Bill Howard and Ben Center. On another occasion, Ben Center was involved in a fracas with J.W. Rector. Ben Center accused Rector of being an informant. Rector later entered Center's home and struck him with a rock. In the ensuing struggle, Rector was seriously injured.

Neither moonshining nor moonshining feuds began to describe all crimes in the Dark Corner. The *State* reported in June 1894 that a Mrs. Plumley had been shot and robbed. The crime occurred during the daylight hours when Mrs. (Crecie) Plumley was home alone. She saw someone enter her home, and when she investigated, the intruder shot and wounded her. He also escaped with a trunk containing $600. A posse tracked the perpetrator around Hogback Mountain to the Van Burwell house. William Plumley, husband of the injured woman, told reporters that only the Burwells had known about the money.

Nevertheless, a mysterious death on the Chester and Lenoir Railroad track seemed to solve the crime. Conductor O.A. Hamlin found a dead man lying across the tracks near Lincolnton. The man died of an apparently self-inflicted gunshot wound to the head. A pistol was in his hand, and he had over $500 on his person. Speculation immediately linked the suicide with the Plumley attack and robbery. However, in June, officials arrested Ben Burwell, recovered the money and charged him with the crime. In March of the following year, Ben Burwell went on trial for the robbery.

Clearly, life in the Dark Corner could be dangerous. On moonlit nights, death walked the quiet byways. Law officers, according to some accounts, walked into the Dark Corner but not out. Lawbreakers such as John Sims, an escaped convict from Columbus, North Carolina, sought refuge in the forested mountains. Residents also died when disagreements ended in gunfire. For example, in 1896 Greenville County authorities arrested Luther

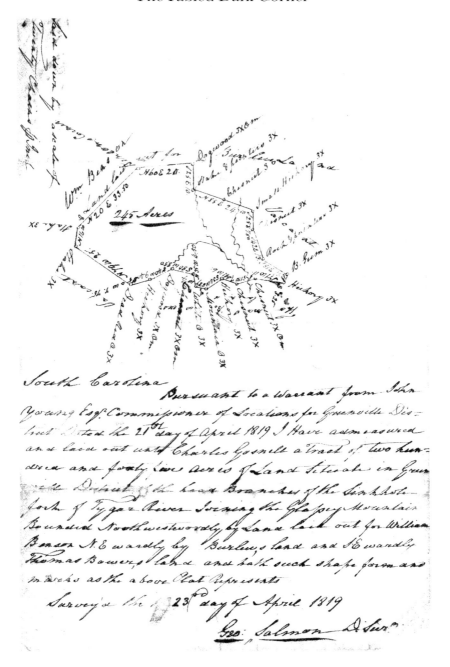

Plat of 245 acres surveyed for Charles Gosnell by George Salmon, April 23, 1819. The land lay on the Sinkhole fork of the Tyger River at Glassy Mountain. *Records of the South Carolina Secretary of State, Office of the Surveyor General, Duplicate State Plats, Bundle 71, plat 148. Courtesy of the South Carolina Department of Archives and History.*

Durham for the murder of Pink (P.C.) Plumbley. Both men were moonshiners, and at the time of Plumbley's death, Durham was out on bond for another murder charge—the death of Dispensary Constable Pettigrew. Reports described Plumbley as "brave [and] generous" but warned of additional violence, as the Plumbleys were also "good haters." The Greenville County coroner investigated. It was his verdict that Plumbley had died by the hand of J.R. Durham. The verdict also named Henry Howard, Will Cade, Vet Ross and Luther Durham as accessories to murder. Feuds and distilling were a dangerous combination.

In his history of the county, Dr. A.V. Huff told another story of Sheriff Gilreath (Greenville County, 1876–1900) and his law enforcement exploits. This case involved Hub Garmany. Garmany was the suspected shooter of a revenue agent. Gilreath, who rarely carried a firearm, talked Garmany into leaving his mountain hideout. As it was late, the sheriff took the accused to his house for dinner and bed. The next morning, the prisoner went to jail. A jury found Garmany not guilty. Similarly, a hung jury in the trial of George and Henry Sudduth for the beating death of an informer named Henson brought them a second trial and an acquittal. The evidence was circumstantial; the deceased's body had been found near the Sudduth home.

Newspapers from the turn of the twentieth century frequently reported stories of authorities raiding and destroying stills, including large two-hundred-gallon distilleries. Raids, however, could turn ugly. In 1906, for example, a joint federal and state operation destroyed eight stills in the Dark Corner. At that time, authorities alleged that some of "the more dangerous moonshiners" had terrorized peaceful residents by firing into churches. Earlier that year, there was a notice that a revenue officer sent from Washington, D.C., to the Dark Corner had disappeared. Reports claimed that the agent had been last seen in the company of a "notorious moonshiner." The report may have been a hoax, but the possibility was real to the Greenville newspaper-reading public. Sometimes shots were exchanged, and state and federal officers arrested suspected moonshiners. In 1907, however, the tables were turned. After a successful raid and arrests, local residents—men and women—staged a successful counterattack, freeing the suspects. In 1910, almost 90 percent of the cases tried during the October term of federal court were moonshine cases. Most of these cases originated in the Dark

A moonshiner firing up his distillery near Caesar's Head. *Photographs, M-PL-GV-2. Courtesy of the South Caroliniana Library, University of South Carolina, Columbia.*

Corner. Despite the number of cases, conviction rates varied, as jurors were loath to accept the testimony of government agents.

In 1907, two former Dark Corner residents, Walter G. Allen and James Suddeth, grabbed headlines across South Carolina. Allen and Suddeth, "two of the most noted criminals of the last decade," escaped from the state penitentiary. Convicted murderers, both were longtime trustees, and Allen was in line for a pardon. At least Allen was apprehended, as in 1910, according to the federal census, Walter Allen was a resident of the Greenville County jail.

In addition to the external threats of revenue agents and sheriff's deputies, residents of the Dark Corner faced internal threats as well. Feuds were common and frequently led to shootings and death. Many died in such exchanges in the communities of Glassy Mountain, Highland, Oak Grove and Gowensville. Though often arrested, the shooters were not always convicted. Forest fires were another threat. For example, in 1913 one raged for days, burning cornfields and barns.

The year 1913 was one of turmoil in the Dark Corner. In addition to the forest fires, there were heightened revenue raids. By September 1913, agents were bragging about their successes. In two months, Deputy Collector

A mountain family in their cabin doorway. *Photographs, 9831.4. Courtesy of the South Caroliniana Library, University of South Carolina, Columbia.*

R.Q. Merrick and E.A. Allen had destroyed fifty illegal stills, arrested sixteen alleged distillers and poured out thousands of gallons of beer. Their territory covered the Upstate—Pickens, Oconee and Greenville, including the "famed Dark Corner." In August, alleged moonshiners had taken their own revenge. Suspecting a local constable of informing on the location of their stills, they had destroyed Constable Green Howard's cotton crop and poisoned five of his cows. Not all agents were celebrating that September. A report published on September 14 stated that agents lay in wait all night to surprise suspected distillers. The attempt went awry when the moonshiners, suspecting a trap, jumped in the river and swam away. It was a long, futile night for the agents.

Yet in the early twentieth century, moonshiners and escaped convicts were not the only news stories from the Dark Corner. In 1919, two Greenville school officials—Elizabeth Perry, supervisor of rural schools, and Carl Drake, attendance officer—found an unknown county school flourishing in the Dark Corner. The school, Mountain Hill, was over two miles from a public road and had twenty-four students. The dream of a high school for northern Greenville began to take form in 1891. John Ballenger lobbied the North Greenville Baptist Association to establish a high school. As a result, North Greenville High School opened on January 16, 1893. North Greenville University in Tigerville is the successor to that dream.

The Dark Corner has gone from an exotic area celebrated for its "otherness" to upscale residential communities and golf courses. The one constant is the land—the coves, hollows and magnificent views. These stories pull back the curtain on a few actors and the parts they played in the rich history of Greenville's fabled Dark Corner.

PROGRESSIVE GREENVILLE

The Real New South

T raditionally, the concept "New South" dates from Henry Grady's famous speech. On December 22, 1886, Grady took the words of Benjamin H. Hill, spoken at Tammany Hall in 1866, and made them the basis for a new vision of the South. Those words were: "There was a South of slavery and secession—that South is dead. There is a South of union and freedom—that South, thank God, is living, breathing, growing every hour." Grady, of Atlanta, preached a new vision for the southern states, one of work, industry and self-reliance—the antithesis of the Lost Cause mentality that wanted to make every relic of the Civil War a holy shrine. For decades after Lee's surrender at Appomattox, the Lowcountry of South Carolina was mired in the Lost Cause. Charleston became an unkempt city, with unpaved streets, wandering livestock, buzzards and unsafe drinking water. In South Carolina, the first stirrings of the New South dogma were in the Midlands and Upstate.

Civic leaders in Greenville embraced the new philosophy. In 1915, businessmen in Greenville opened the Southern Textile Exposition. The trade show celebrated the strength of the textile industry and also functioned as a forum to share new ideals. The event was so successful that Greenville became the home of the Southern Textile Association's trade show, which had a permanent home—Textile Hall—in Greenville. Textile mills had opened in Greenville and other Midland and Upstate counties during the 1880s. In the ensuing decades, mills proliferated. The F.W. Poe Manufacturing Company of Greenville employed between nine hundred and one thousand workers.

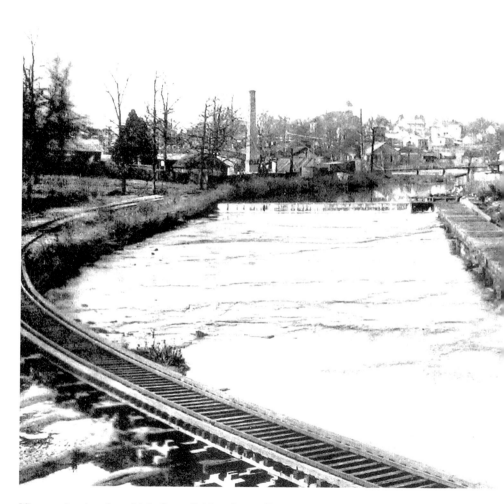

View up the river from Main Street Bridge, Greenville, 1895. Art Work Scenes of South
Carolina. *Courtesy of the South Caroliniana Library, University of South Carolina, Columbia.*

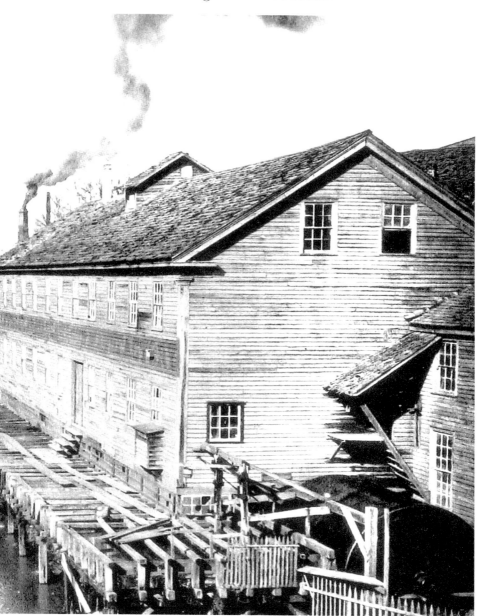

In the early twentieth century, Greenville was home to the textile empires of John T. Woodside and Lewis W. Parker. By 1930, there were 35 textile plants in Greenville County, and within a radius of one hundred miles, there were 467. Greenville was the "Textile Center of the South."

Electricity came to Greenville in 1888. The gubernatorial election in 1907 highlighted Greenville's economic and political strength. South Carolinians elected Martin F. Ansel, of Greenville, as South Carolina's first Progressive governor. Elected in 1907, the reform-minded Ansel served until 1911. Ansel advocated the establishment of new high schools across the state. Later, he also campaigned for Woodrow Wilson. Progressivism, as it developed in South Carolina, was a logical outcome of a "New South" mentality. South Carolina Progressives focused on education, health, parks, hospitals and libraries. Civic competitiveness and pride mingled with efforts to eliminate child labor, encourage vaccinations and address the high level of illiteracy in the state. Women in Greenville organized suffrage groups.

The Greenville of the early twentieth century had the hallmarks of the Greenville of the twenty-first century—pride in its accomplishments, pride in its diverse economy, pride in its educational institutions and pride in its cities and towns. It was a place with hidden stories, treasured memories and enduring mountains, and yet it was a place confident of the present and the future.

ADDITIONAL READING

Ashmore, Nancy Vance. *Greenville: Woven from the Past*. Northridge, CA: Windsor Publications, 1986.

Batson, Mann. *A History of the Upper Part of Greenville County*. Taylors, SC: Faith Print Co., 1993.

Crittenden, Stephen S. *The Greenville Century Book*. Greenville, SC: Press of Greenville News, 1903.

Huff, Archie Vernon, Jr. *Greenville: The History of the City and County in the South Carolina Piedmont*. Columbia: University of South Carolina Press, 1995.

Richardson, James M. *History of Greenville County, South Carolina*. Atlanta, GA: A.H. Cawston, 1930.

Willis, Jeffrey R. *Remembering Greenville: Photographs from the Coxe Collection*. Charleston, SC: Arcadia, 2003.

The falls, Greenville. *Courtesy of William E. Benton.*

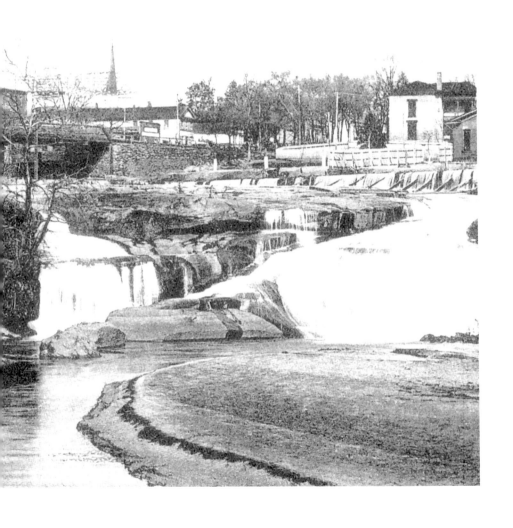

INDEX

INDEX

Index

INDEX

INDEX

INDEX

INDEX